Postcard History Series

Kennett Square

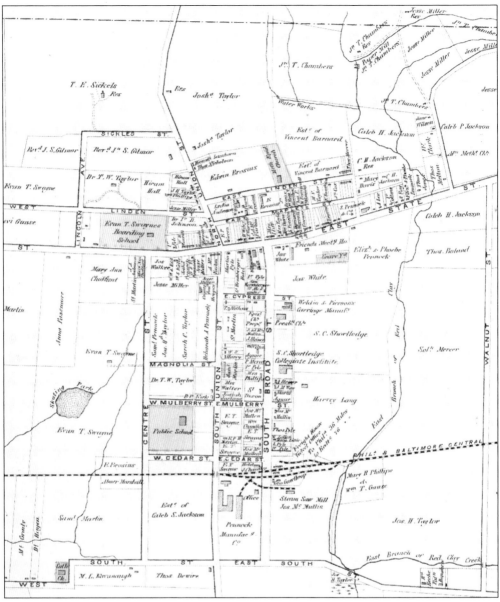

KENNETT SQUARE, 1873. This map of Kennett Square Borough in 1873 is from the *Witmer Atlas of Chester County.*

On the front cover: This photograph shows the firemen's auditorium in 1929. (Courtesy of the Chester County Historical Society.)

On the back cover: Taken from a lantern slide, Evan P. Green's general store is seen here in 1866. (Courtesy of the Bayard Taylor Memorial Library.)

Postcard History Series

Kennett Square

Joseph A. Lordi

Copyright © 2006 by Joseph A. Lordi
ISBN 978-0-7385-4529-5

Published by Arcadia Publishing
Charleston, South Carolina

Printed in the United States of America

Library of Congress Catalog Card Number: 2006923083

For all general information contact Arcadia Publishing at:
Telephone 843-853-2070
Fax 843-853-0044
E-mail sales@arcadiapublishing.com
For customer service and orders:
Toll-Free 1-888-313-2665

Visit us on the Internet at www.arcadiapublishing.com

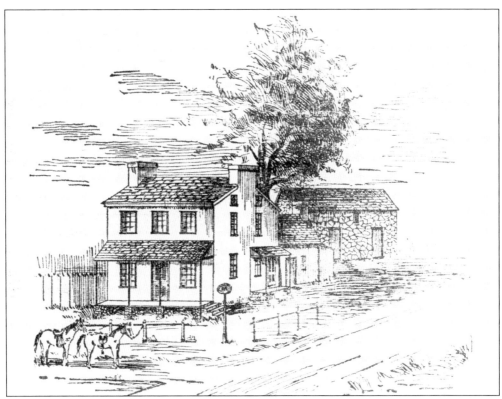

UNICORN TAVERN. The tavern was built about 1735, and by 1764, it may have been in the hands of Joseph Musgrave, the founder of Kennett Square. Fire destroyed the original tavern in December 1776; a new tavern was built, but on January 25, 1875, it too was destroyed by fire and was never rebuilt. Dr. Isaac D. Johnson, a local homeopathic physician and inventor, drew the sketch from memory.

Contents

Acknowledgments 6

Introduction 7

1. The Business Section 9

2. Transportation and Industry 41

3. Cultural and Educational Institutions 55

4. Religious Institutions 65

5. Neighborhoods and Streetscapes 77

6. Bayard Taylor, Waywood, and Longwood 101

7. Sports, Recreation, and Miscellaneous 121

Acknowledgments

I would like to extend my appreciation to the Bayard Taylor Memorial Library for the use of all the photographs and glass lantern slides used in this book; to my friend and neighbor Dolores I. Rowe for the use of several of her postcards; and finally to my longtime friend and editor, Michael R. Cooney, for his constant prodding, without which this project would not have materialized.

INTRODUCTION

Located between the east and west branches of the Red Clay Creek (Hwikakimensi to the Native Americans) in southeastern Chester County, Kennett Square began as a crossroads in the early 18th century. At the time the European settlers arrived in the Kennett region, it was populated by the Unami clan of the Lenni-Lenape Indians, an Algonquian-speaking people. The area was most likely used as a smoke signal center. The name Kennett originates with Francis Smith, who came to the region in 1686 and owned 200 acres at the mouth of the Pocopson Creek. He was a native of Devizes in Wiltshire, England, where there is a village called Kennet on the Kennet River. The first mention of Kennett (Township) in Chester County appears in court records for February 1705.

One of the first land purchasers in what is now the borough of Kennett Square was Gayen Miller, who bought 200 acres from Letitia Aubrey (née Penn), daughter of William Penn, in 1702. Part of this acreage included the eastern part of the present borough. Miller and his wife Margaret built a house in 1716 in the 100 block of South Walnut Street. Later, in 1764, Joseph Musgrave purchased land from Joseph Walter in the northeastern part of the borough along State Street. At that time, he built a two-and-a-half-story brick home on the southwest corner of Sycamore Alley and East State Street. This property would be enlarged to become the future Kennett Hotel. The first recording of the name Kennett Square appears on an application for a tavern license in 1765, about the time Musgrave was trying to lay out his new town. By 1776, Musgrave had sold this property to Col. Joseph Shippen, the uncle of Peggy Shippen, who became the wife of Benedict Arnold.

Some of the original family names of the first inhabitants include Bailey, Chandler, Cloud, Gregg, Harlan, Kirk, Miller, Peirce, Pusey, Pyle, Swayne, and Way—names that are still familiar today.

At the time of the Revolutionary War, Kennett was a small village including the Unicorn Tavern, the Shippen brick mansion, a few scattered log cabins, and surrounding farms. Before the Battle of the Brandywine, Kennett Square was occupied by approximately 5,000 Hessian troops and 13,000 British regulars. The Battle of the Brandywine, September 11, 1777, was the largest battle of the Revolutionary War. By 1810, Kennett was considered one of the largest towns in the area, with about eight dwellings. During the War of 1812, Gen. Robert Bloomfield encamped in Kennett Square and used the Shippen home as his headquarters.

By 1853, Kennett Square had a population of about 300, and by 1860, the census shows 606 inhabitants. After much debate among the citizens of Kennett Township and the villagers of Kennett Square, the town was finally incorporated as a borough on March 13, 1855. Antebellum

Kennett was an important region in the Underground Railroad, and many prominent citizens of Kennett Square and the surrounding area played an important role in securing freedom for runaway slaves. During the Civil War, volunteers from Kennett Square, under the leadership of Charles Frederick Taylor, became Company H of the Bucktails.

Many industries helped Kennett grow, including Samuel and Moses Pennock's agricultural manufacturing company in the 1840s, the railroad in the late 1850s, greenhouses, the mushroom industry, and the Fibre Specialty Manufacturing Company (later National Vulcanized Fibre Company). Inventors such as James Green (the hay knife), Bernard Wiley (the Wiley plow), John Chambers (the asbestos stove plate), and Cyrus Chambers (brick-making and paper-folding machines) were from the area, as were the famous 19th-century author, diplomat, poet, and journalist Bayard Taylor (1825–1878) and hall of famer Herbert Jefferis "Herb" Pennock (1894–1948), a New York Yankees pitcher. Another important person was William Swayne, who in 1896 constructed the first successful mushroom house. From its humble beginnings on Apple Alley, the local mushroom industry became the largest in the United States, thus earning Kennett Square the title "Mushroom Capital of the World." Today there are no mushroom houses in the borough, most being located in the surrounding townships, Toughkennamon, and Avondale.

The first European inhabitants of Kennett Square were mostly English and Irish Quakers. The Scotch-Irish followed them and then, in the mid-19th century, Irish Catholic immigrants. The first African Americans are known to have been in Kennett Square by 1816, and by the late 19th century, Italian immigrants began to arrive. The Italians worked for the railroad and in the stone and clay quarries of the region; later they began working in the greenhouses and mushroom and service industries. During the late 1930s and World War II era, there was an influx of residents from eastern Tennessee and southwestern Virginia. Many of these new arrivals worked in the defense industry in the Susquehanna and Delaware River Valleys. By the mid-20th century, Puerto Ricans began to settle in the area, and by the end of the century, immigrants from Mexico began to work and settle in Kennett Square. They, like the Italians before them, are now working in the mushroom and service industries.

Because of suburbanization and a greater reliance on the automobile, Kennett Square's heyday as an industrial and commercial center (like many other American small towns) now seems to have passed. But thanks to the golden age of postcards, Kennett Square's proud history will always be with us.

—Joseph A. Lordi

One

THE BUSINESS SECTION

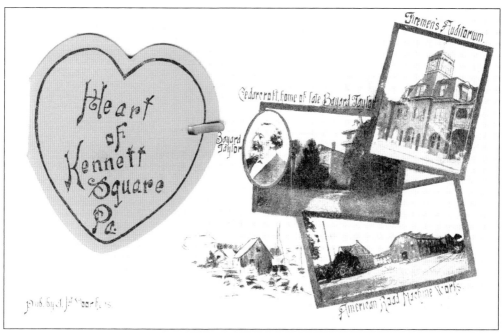

HEART OF KENNETT SQUARE. Published by John H. Voorhees about 1910, this postcard shows the firemen's auditorium, Cedarcroft with Bayard Taylor, and the American Road Machine Works. However, if the metal tab is bent back, the die-cut heart opens to reveal an "accordion" of 13 tiny Kennett Square views. Similar postcards are to be found for many towns across the United States from this era.

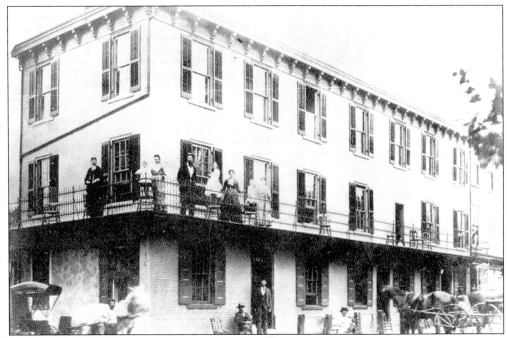

THE KENNETT HOTEL. The east end of the Kennett Hotel was built in 1768 by Joseph Musgrave, founder of Kennett Square. The photograph used for this 1909 postcard dates to 1883 when Isaac K. Pyle was the proprietor.

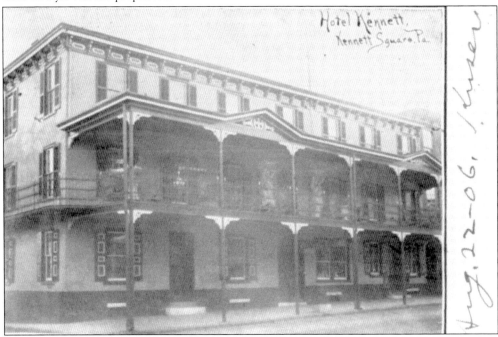

THE KENNETT HOTEL VERANDA. In 1776, Musgrave sold his home to Col. Joseph Shippen. Shippen was the uncle of Peggy Shippen, who married Benedict Arnold, the Revolutionary War patriot and traitor. In the 1790s, he sold the property to Jessie Sharp. The iron veranda was added in July 1881.

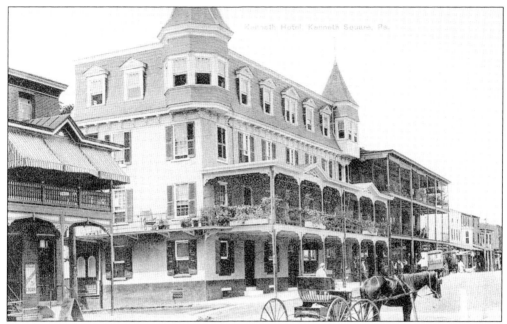

THE FIRST POST OFFICE. By 1804, Sharp had a store and post office (established in 1802 with Benjamin Taylor as the first postmaster) in the building. At that time, it was then sold to John Taylor, grandfather of Bayard Taylor. John Taylor was the second postmaster and served in that capacity from 1805 to 1824.

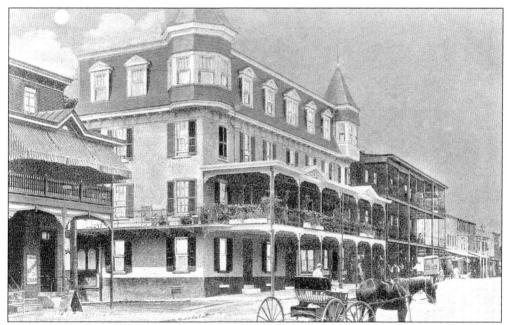

UPTOWN IN THE MOONLIGHT. About 1810, John Taylor built the middle section of the building, and in 1831, he sold it to Harlan Gause, who then turned the building into a hotel. By 1847, the hotel served as a stop on the stagecoach route between Philadelphia and Baltimore.

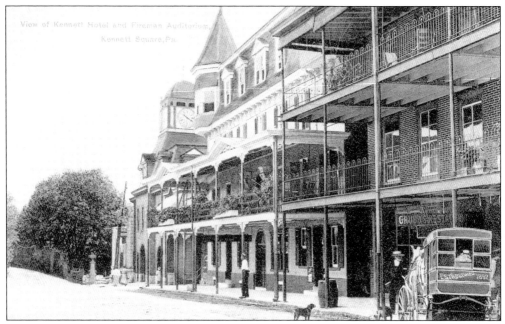

THE OLD PLOW TAVERN. In 1855, Bernard Wiley, inventor of the Wiley plow, built the west section of the hotel. At that time, it was known as the Plow Tavern. Note the horse-drawn carriage, which served as a taxi from the railroad station to uptown.

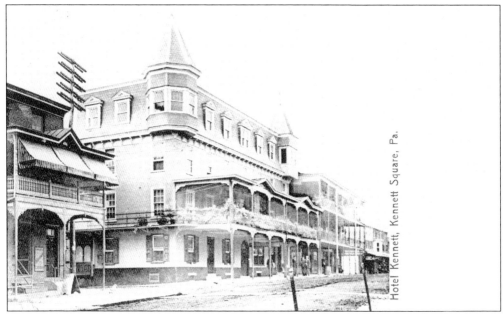

ISSAC K. PYLE'S HOTEL. Isaac K. Pyle added the third floor in 1880. To the left is the cigar emporium of Robert Walker, and to the right is the Swayne Block.

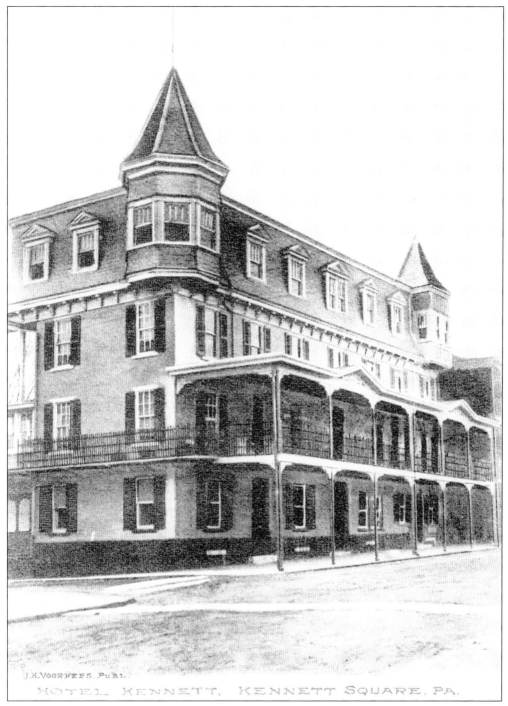

THE END OF AN ERA. In 1950, the hotel was purchased by CKFC Company. It did extensive renovations to the hotel and reopened it on September 28, 1951. But tragically, on August 5, 1952, the interior of the hotel was destroyed by fire. The hotel was demolished in December 1953, and a J. J. Newberry's variety store was built on the site. Newberry's opened for business on March 17, 1955, and was in operation until 1995.

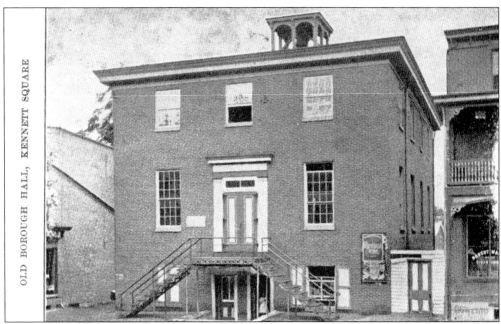

OLD BOROUGH HALL. Built by Thomas Pyle and completed in 1858, it was torn down in 1905 to make way for the firemen's auditorium. Between 1875 and 1889, Augustus Silver, a businessman of some renown, operated a restaurant and ice-cream parlor in the basement of borough hall. The image dates from before 1904.

SOCIAL MEETING PLACE. Many social functions were held in the large hall on the second floor, including temperance meetings, and balls and banquets to benefit the local lyceum, social organizations, and the two circulating libraries. The last play in the old borough hall was held on July 12, 1905.

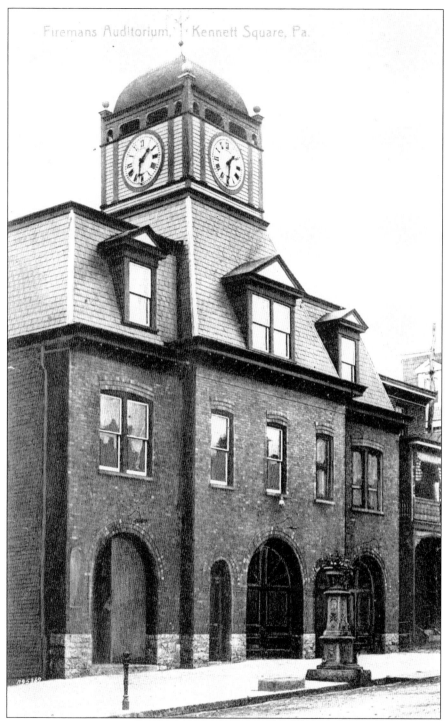

FIREMEN'S AUDITORIUM. The Kennett Fire Company was organized in 1875 and located in a small building on Maple Alley. In 1905, a new building, costing $18,000, was constructed on land deeded to the fire company by borough council. The building housed the fire company, borough offices, and the jail. Vernon T. Beeby was the builder.

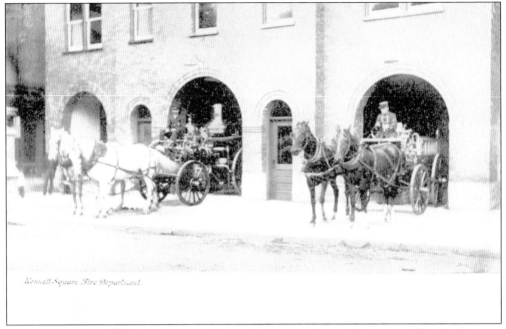

FIRE EQUIPMENT. This early postcard shows the fire engines and horses used by the Kennett Fire Company soon after the new firemen's auditorium was constructed.

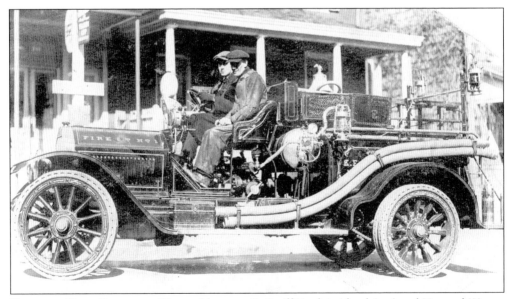

KENNETT FIRE COMPANY. Pictured here are F. Graff Sinclair (the driver) and Howard Kinsey on one of the fire trucks used by the Kennett Fire Company. (Courtesy of Don Sinclair.)

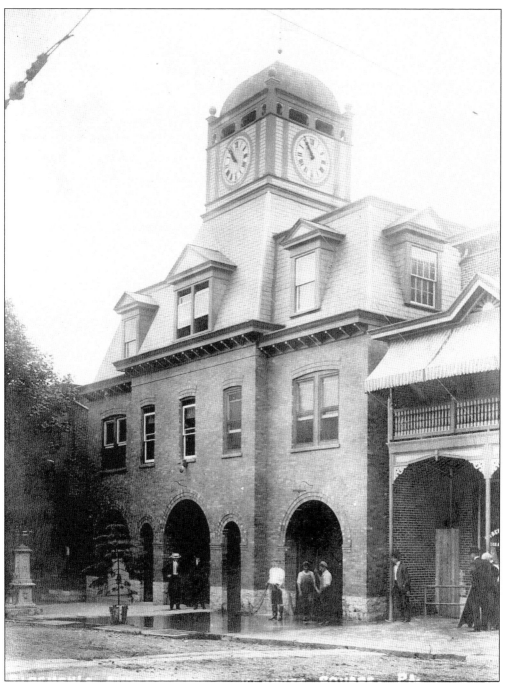

FIREMEN'S AUDITORIUM, 1908. Here is the firemen's auditorium about 1908. The clock tower, often used as the symbol of the borough, was recently used in the logo for the 150th anniversary of Kennett Square in 2005. When the building was torn down in 1965, the old clock was saved, restored, and, in 1998, placed in the tower of the Genesis HealthCare building. Note the gentlemen hanging around Walker's Cigar Emporium and billiard hall. Today the building is known as the Kennett Cafe—a tavern.

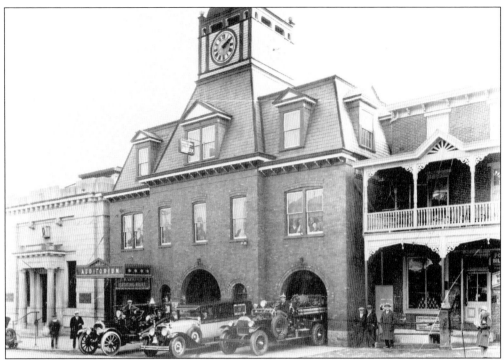

FIREMEN'S AUDITORIUM MOVIE MARQUEE. This wonderful photograph shows, from left to right, the National Bank of Kennett Square, firemen's auditorium, and Walker's Cigar Emporium in 1929. (Courtesy of the Chester County Historical Society.)

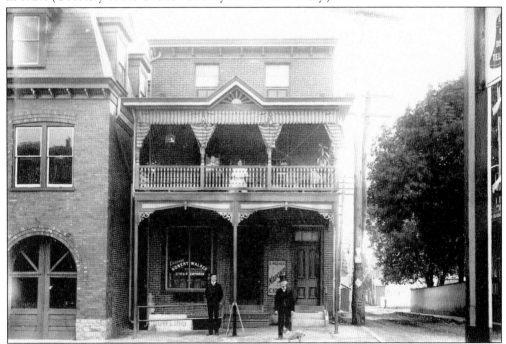

WALKER'S CIGAR EMPORIUM. Pictured here are Robert Walker and his son Price in front of his establishment at 120 East State Street and Sycamore Alley.

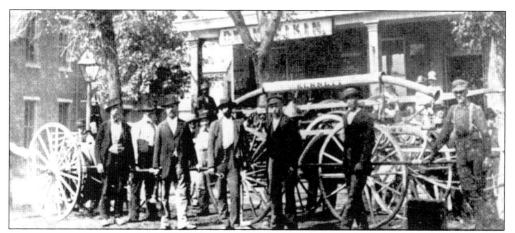

KENNETT FIRE COMPANY'S FIRST PUMPER. Taken in front of Davis W. Entriken's store about 1879, the secondhand pumper (dating from 1835 to 1845) was purchased for $525 from the Reliance Fire Company of Philadelphia in 1875. (Courtesy of Anthony [Tony] Talamonti, Kennett Square Fire Department.)

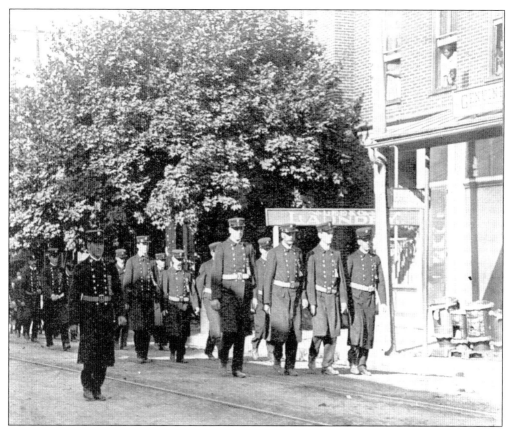

PARADE OF FIREMEN. Here is a group of firemen in an 1881 Fourth of July parade in front of Lee's Laundry located at 115 West State Street.

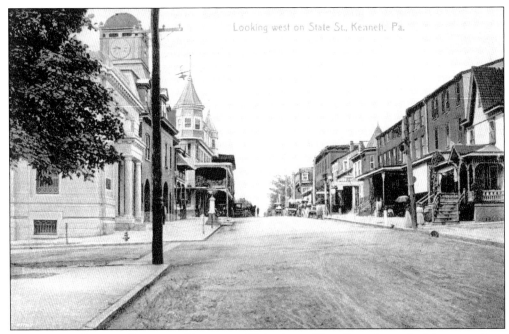

EAST STATE STREET BUSINESS DISTRICT. This view of East State Street looking west dates from 1910 and was published by W. H. Tegeler of West Grove.

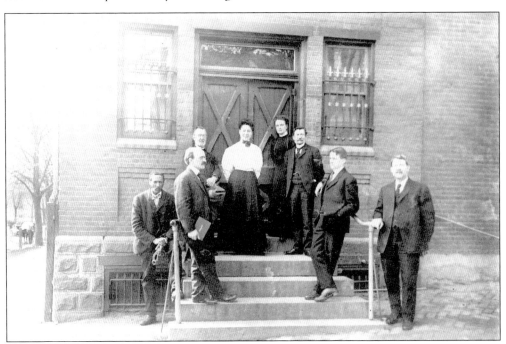

THE OLD BANK BUILDING, APRIL 19, 1908. This was moving day for the bank employees who went into temporary quarters until a new bank building was constructed. Employees pictured are, from left to right, Samuel Robinson, janitor; Morton P. Darlington, assistant cashier; Edward B. Darlington, president; B. Muriel Swift, paying teller; Mary B. Richards, bookkeeper; Lewis Marshall, clerk; an unidentified gentleman; and D. Duer Philips, cashier.

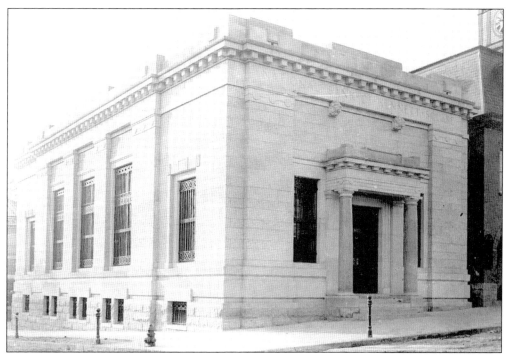

Dr. Alban Way's Property. Before 1881, there was no banking establishment in Kennett Square. In 1881, the National Bank of Kennett Square was founded and located on land belonging to Dr. Alban Way, a dentist. The first bank was on the corner. Next door was I. Eugene Chandler's pharmacy.

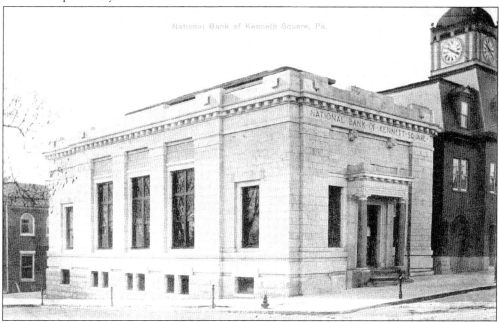

First Bank in Kennett Square. A new bank building was constructed in 1908. To the rear of the bank building one can see the north wall of the Bayard Taylor Memorial Library. This classic-style building was "modernized" in 1955.

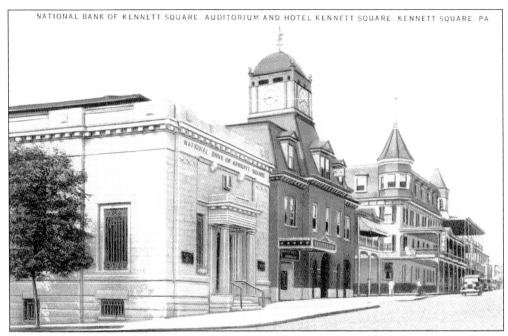

THE BUSINESS OF BANKING. In 1931, the bank advertised such labor-saving devices as typewriters, the Telautograph, and the Recordak. A thousand checks per day were handled.

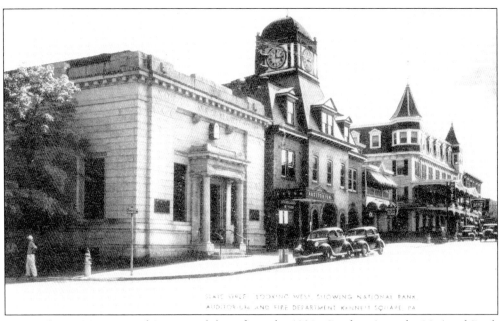

EARLY BANK MERGER. This postcard dates from the 1930s. By that time, the National Bank of Kennett Square had merged with the Kennett Trust Company to become the National Bank and Trust Company of Kennett Square.

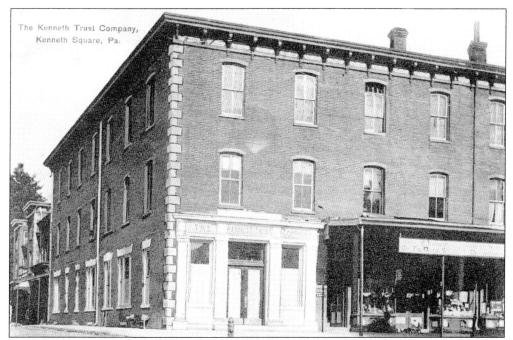

KENNETT TRUST COMPANY. The Kennett Trust Company opened for business on January 2, 1907, with Harry W. Chalfant, president, S. Jones Philips, vice president, and J. Walter Jefferis, treasurer. On June 17, 1930, the Kennett Trust Company merged with the National Bank of Kennett Square to become the National Bank and Trust Company of Kennett Square.

KENNETT TRUST COMPANY, 1912. Here is the Kennett Trust Company and, to the right, the mercantile establishment of John H. Voorhees, R. M. Rakestraw's men's shop, and the construction site of Charles B. Harvey's new drugstore.

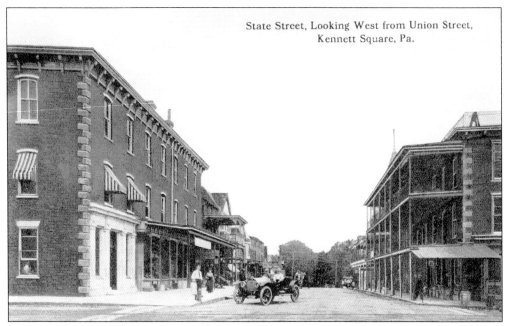

KENNETT TRUST COMPANY, 1918. On the left of this 1918 postcard is the Chalfant Block, and to the right is the Swayne Block, which was built in 1878.

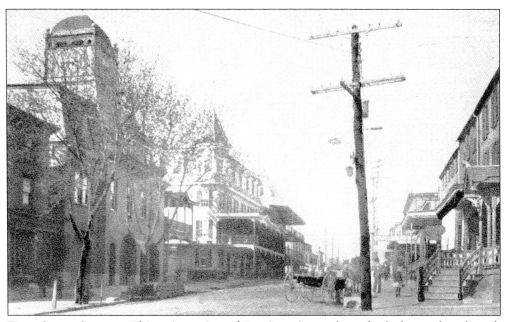

EAST STATE STREET. This unique view of East State Street shows both the north and south side of the street about 1908.

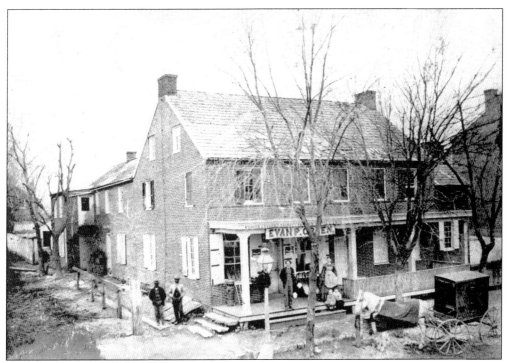

GENERAL STORE OF EVAN P. GREEN. This 1866 image shows the general store of Evan P. Green at the northeast corner of State and Union Streets. In 1881, it was torn down and replaced by the Chalfant Block. Today the Genesis HealthCare building stands on the spot.

WEST STATE STREET. Here is a view of West State Street from Union Street about 1909. To the right is the Unicorn Block, built in 1877 by Theophilus Ellsworth Sickels. Note the trolley tracks leading to Toughkennamon, Avondale, and West Grove.

CHALFANT BLOCK BUSINESSES. This Kodak postcard shows the hardware store of John H. Voorhees and the variety store of J. R. Hosch. Voorhees came to Kennett Square in 1895 and was proprietor of various businesses until 1972. Hosch was in business from 1944 until the late 1950s.

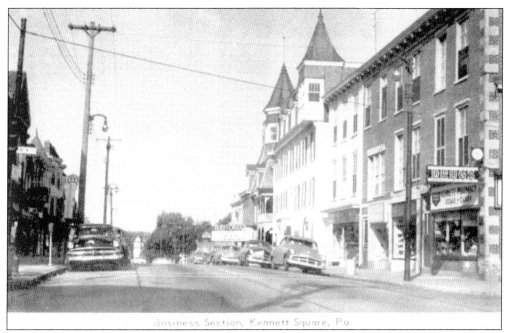

STATE STREET BUSINESS DISTRICT. This pre-1952 postcard shows the Kennett Hotel and Donnelly's Drugstore (on the right) in the Swayne Block. On this corner once stood a structure where Bayard Taylor (local author and poet) was born.

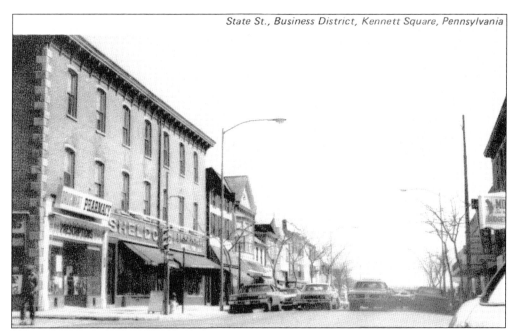

BUSINESS DISTRICT. Beginning at the left and moving east are the Drugmart Pharmacy, Sheldon's department store, Tingle's Men's Shop, and the state liquor store. These stores flourished from the 1950s into the early 1990s. Sheldon's closed in 1992.

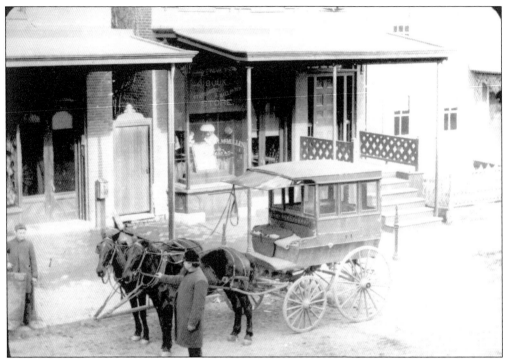

OLD POST OFFICE. This 1893 or 1894 glass lantern slide image shows the carriage of Frank Carl Maxwell, local expressman, in front of the post office at 111 East State Street. The next store, at 113 East State Street, was the Kennett Book Store of E. T. and A. R. McMullin. In 1884–1885, it was also a bookstore, operated by J. W. Bowman.

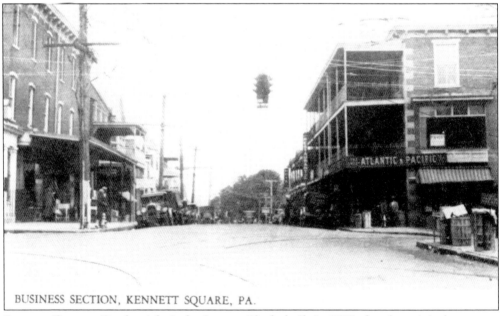

SWAYNE BLOCK. On the right is the Swayne Block, built in 1878 after the original structure was destroyed in a fire in 1876. The first Atlantic and Pacific grocery store in the borough was located on the corner for many years.

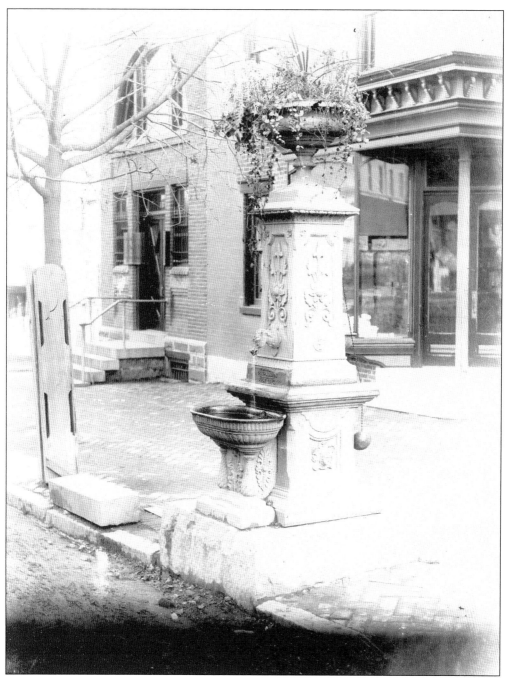

PUBLIC DRINKING FOUNTAIN. The fountain was erected in July 1892 in front of the old borough hall. To the left is the original National Bank of Kennett Square, and to the right is the drugstore of I. Eugene Chandler. The words "Humanity" and "Compassion" are found on the panel below the horse head. The fountain was made of metal and was removed at the end of December 1921. The photograph dates from before 1908.

GAUSE HOUSE, 1890. This early image shows the home of Lydia "Lib" Gause at 117 East State Street. She inherited the property from Levi Gause in 1894 and later sold it to Charles B. Harvey in 1912. Harvey then demolished the building and built a modern drugstore. Harvey operated the business until 1922, at which time it was sold to Harry S. Courson. In 1938, it became Freter's drugstore. Later it was a state liquor store. To the right of the Gause house is the property at 119 East State Street that once housed Bernard D. Bolen's food market.

C. B. HARVEY'S DRUG STORE, 1908. Standing outside of C. B. Harvey's Drug Store at 107 East State Street are, from left to right, Elwood Marshall, Louis Agnew, Fredrick F. MacDonald (a partner of Harvey's), and Willis Taylor. Harvey opened his store in 1893 and was at this location until 1912. At that time, H. A. Rothrock, an ophthalmologist, was also located at this address—note the eyeglasses under the sign.

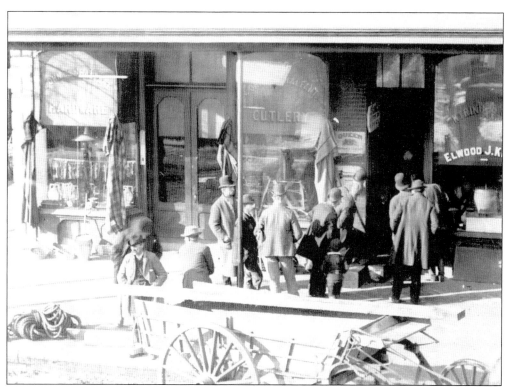

CHALFANT BLOCK, C. 1890. These two photographs show the store of John M. Chalfant on the right and that of Elwood J. Kerns on the left. The sign on the picture below says Public Telephone Office.

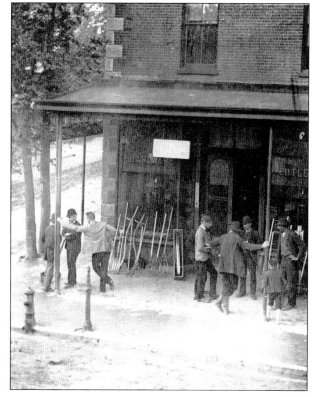

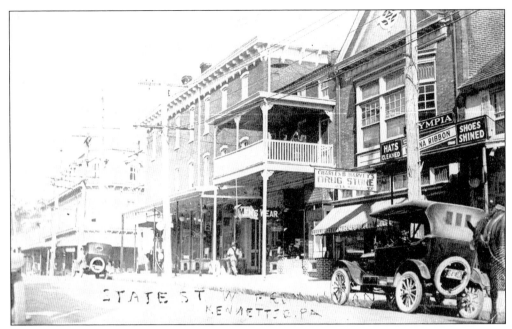

HARVEY'S DRUG STORE. Charles B. Harvey's Drug Store was located at 117 East State Street. Originally it was the property of Lydia Gause, whose home was demolished to build the store. The state liquor store was the last establishment in the building before it was torn down in 1996. (Courtesy of Dolores I. Rowe.)

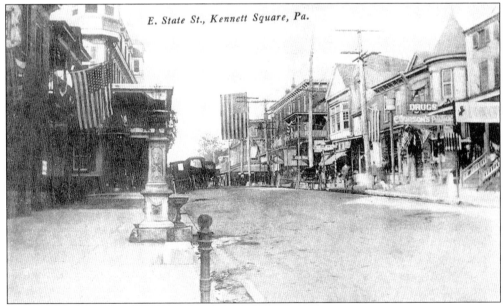

COURSON'S DRUG STORE. Theodore Yarnall, the proprietor of the Yarnall News Depot at 116 West State Street, published this postcard before 1924. Note the public fountain and drugstore of Harry S. Courson in the middle of the block.

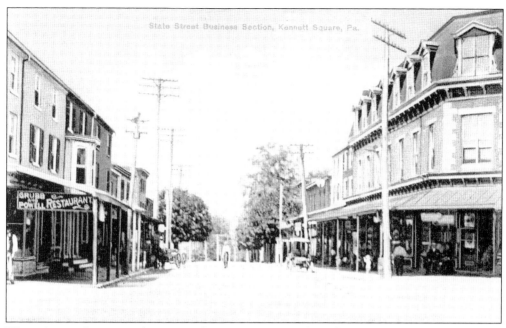

WEST STATE STREET. This view of West State Street dates from about 1908 and shows the Grubb and Powell Restaurant on the left at 100 West State Street. The last commercial business at this location was Stephen's Men's Wear.

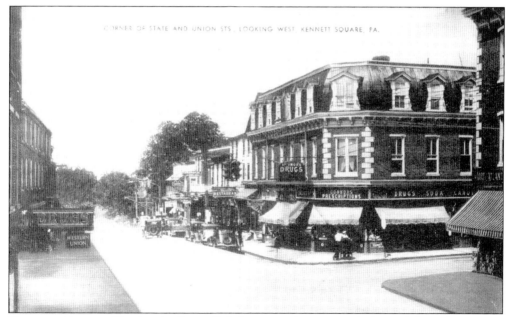

UNICORN BLOCK. The sign for Donnelly's Drugs can be seen on the lower left, with Connor's drugstore on the right. Kennett Square was blessed with many drugstores (and their popular soda fountains).

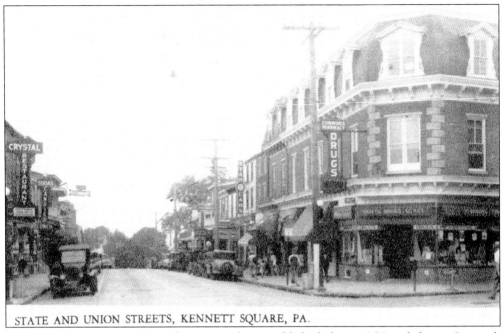

STATE AND UNION STREETS, KENNETT SQUARE, PA.

UNICORN BLOCK, C. 1935. This postcard was published about 1935 and shows Connor's drugstore on the corner of the Unicorn Block. The Crystal Restaurant is located across the street. Star Cars was in the building owned by Herman Schmaltz.

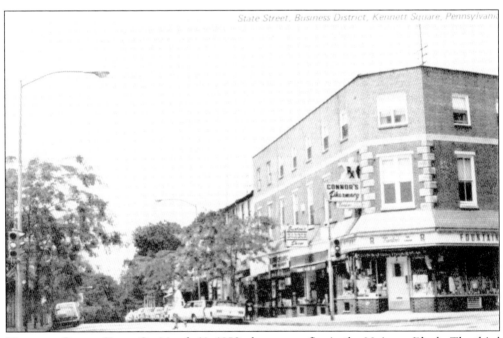

UNICORN BLOCK FIRE. On March 11, 1952, there was a fire in the Unicorn Block. The third floor was rebuilt but not in the style as pictured in the postcard above. Burton's Barber Shop, still operating today, can be seen on the right, next door to Connor's drugstore. Today there is an upscale beauty salon at this location.

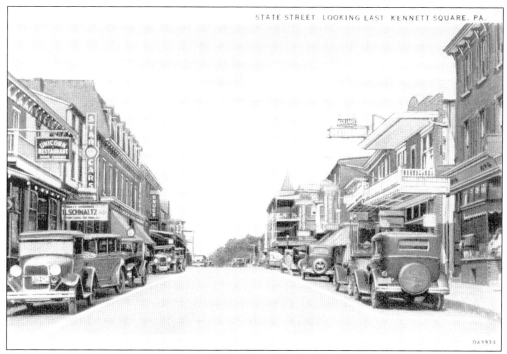

WEST STATE STREET BUSINESS DISTRICT. In the 1930s, State Street was a two-way street. On the right are the Unicorn Restaurant, Star Cars, and H. Schmaltz and Company. Across the street is the sign for the Square Restaurant.

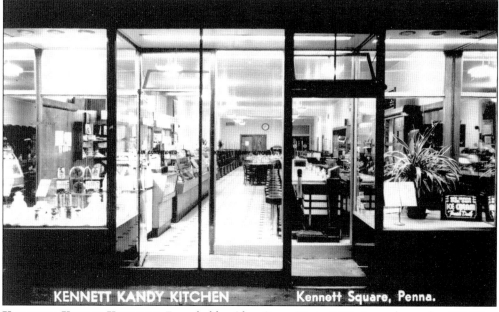

KENNETT KANDY KITCHEN. Founded by Alex Cozanitis in 1923, it was located at 108 West State Street. The Cozanitises were famous for their meals, especially the mushroom soup. The business was in operation until 1970. The Half Moon Restaurant and Saloon is now located on the premises.

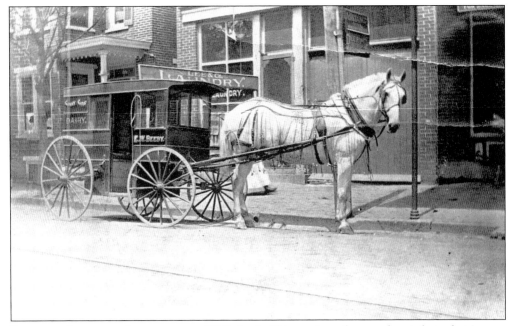

LEE AND COMPANY LAUNDRY, C. 1881. Lee's Chinese Laundry was located at what is now 115 West State Street. J. P. Hannum was the agent behind the establishment of this business, for which he wanted "genuine Chinamen." Hop and Sam Lee were hired to run the business. Note the dairy wagon of E. W. Beeby. (Courtesy of Dolores I. Rowe.)

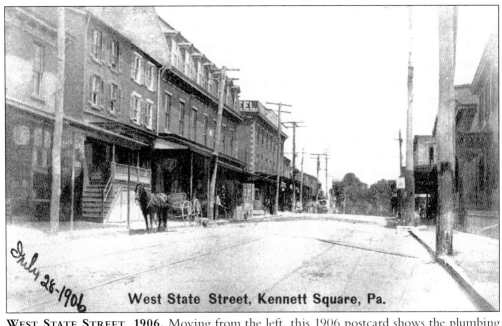

WEST STATE STREET, 1906. Moving from the left, this 1906 postcard shows the plumbing and steam heating store of Charles Thomas, his home at 111 West State Street (with the horse cart in front), a millinery and notions shop, a barbershop, a grocery store, a jewelry store, and, on the corner, a dry goods store.

JAMES M. WORRALL, 1927. This postcard was produced in 1927 and shows the business of James M. Worrall located at 109 South Broad Street. Worrall was Ford's first direct factory agent in Kennett Square. Today Harrington's Coffee Company and Nesting Feathers, an antiques mall, is located here. (Courtesy of Dolores I. Rowe.)

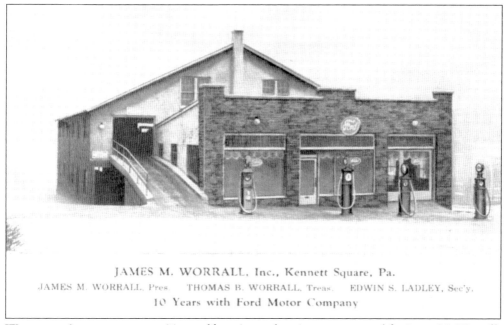

WORRALL ADVERTISEMENT. Pictured here is an advertisement postcard for James M. Worrall. The back of the card lists prices for cars; for example, a roadster sold for $501.50 (equipped and delivered) and a town sedan for $709.50!

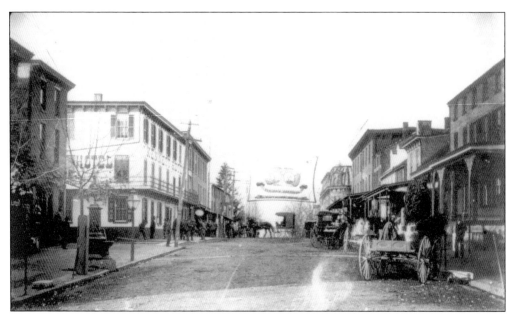

ELECTION DAY, 1892. Anna Belle Swayne, a local photographer, took this photograph on Election Day in 1892. The view looks west on East State Street from Broad Street. The political banner in the middle of the street is promoting candidates Benjamin Harrison and Whitelaw Reid.

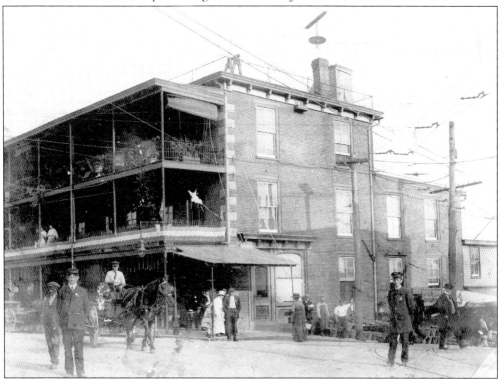

SWAYNE BLOCK, C. 1900. In the 1850s, George P. Davis had his store at this location. The building was destroyed by fire in 1876, and the Swayne Block was erected. On August 16, 1878, the newly erected building was also destroyed by fire, but it was replaced soon afterward.

WEST STATE STREET HOUSES. Here is an 1890 view of West State Street taken from a glass lantern slide. The three Georgian-style row houses to the right still stand at 125–129 West State Street. According to a date stone (with the initials J. R. S.), they were built in 1837.

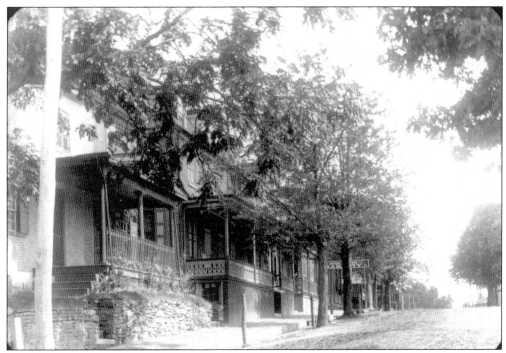

EASTWARDLY VIEW OF WEST STATE STREET. This 1890 view looks east up West State Street from near the corner of Center Street. Note the bakery sign of Adam Nolte at 121 West State Street.

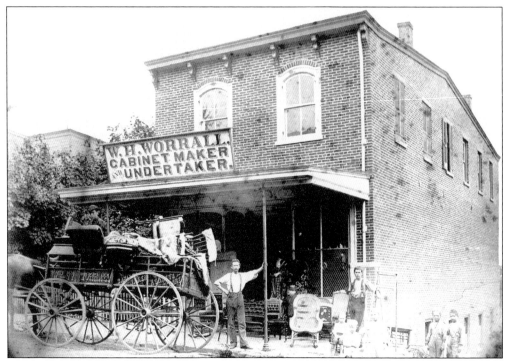

W. H. Worrall's. This 1890 photograph shows the establishment of William H. Worrall (1836–1924) located at 126 West State Street. Two more buildings were constructed to the west, now 128–130 West State Street.

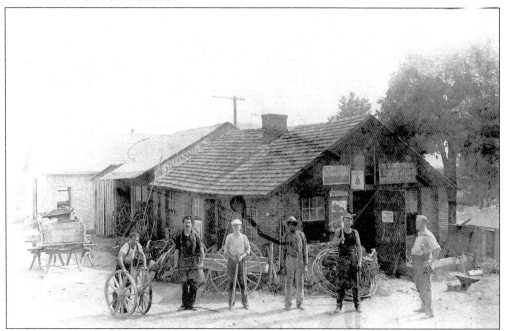

Moynihan's Blacksmith Shop, c. 1900. This shop was located on the southeast corner of West State and Center Streets. Alvin's department store was later built on this site. Today the building is being used as offices for Genesis HealthCare.

Two

Transportation and Industry

"**Better Ve All Go.**" This generic postcard dates from 1914 and was published by the Barton and Spooner Company, Cornwall-on-the-Hudson, New York. The local publisher simply added the name of Kennett Square to give it some local interest.

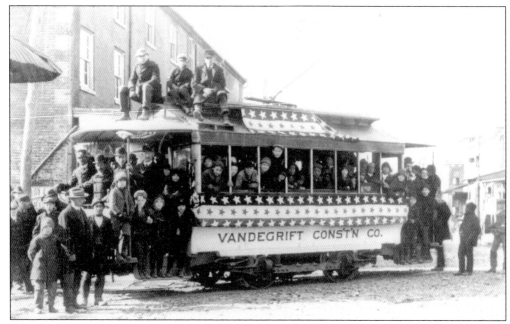

FIRST TROLLEY RIDE. This image shows the maiden run of the Vandergrift Construction Company's Kennett trolley on Saturday, January 30, 1903. Kennett Square was served with two trolley lines—the West Chester, Kennett and Wilmington Electric Railway Company and the West Chester Street Railway.

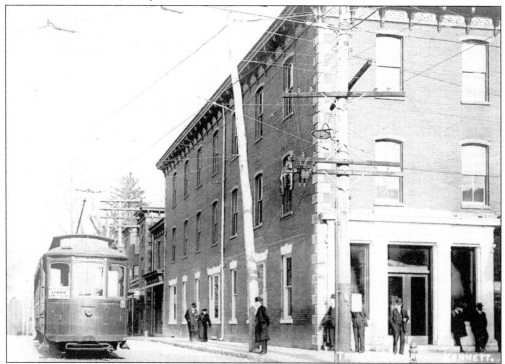

WEST CHESTER TROLLEY. The West Chester–bound trolley is shown in this 1908 postcard. To the right are the Chalfant Block and the Kennett Trust Bank. (Courtesy of Dolores I. Rowe.)

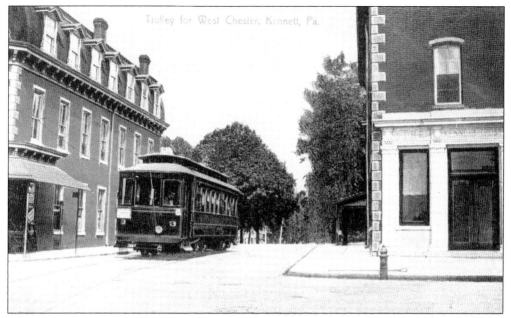

TROLLEY NO. 3. Here is the West Chester Street Railway No. 3 West Chester trolley on North Union Street. To the left is the east side of the Unicorn Block. Through service to West Chester began on Saturday, November 19, 1904.

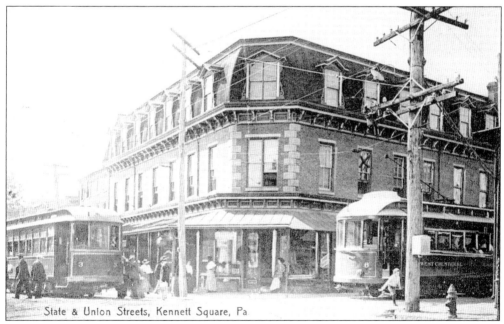

UNICORN BLOCK TROLLEYS. Here are trolley No. 3 to West Grove and trolley No. 6 to West Chester in front of the Unicorn Block. This beautiful, and hard-to-find, postcard was published by local pharmacist Watson J. Berkstresser in 1909.

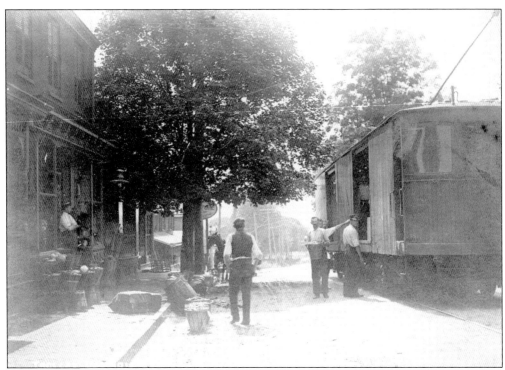

FREIGHT TROLLEY. This very rare postcard shows one of the West Chester, Kennett and Wilmington Electric Railway Company's trolleys unloading freight in front of 120 West State Street in 1909. The freight trolleys proved more successful for the line than passenger service.

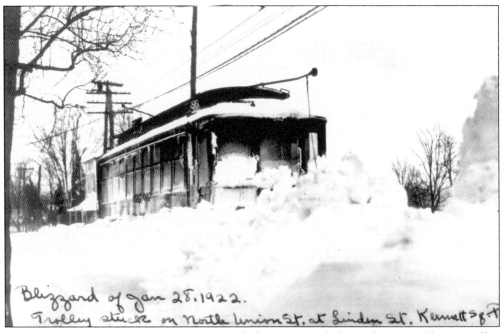

BLIZZARD OF JANUARY 28, 1922. This real-photo postcard shows the West Chester trolley stuck on North Union Street during the blizzard of January 28, 1922.

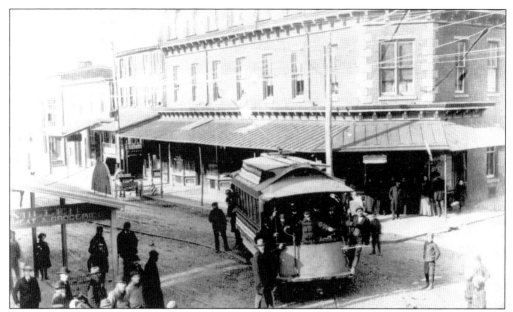

UPTOWN BUSINESS DISTRICT, 1903. This 1903 photograph shows the West Grove trolley turning south onto Union Street. The trolley route took it from West Grove to Brandywine Springs Park in Delaware. By 1906, through service to Wilmington was available—a 1.75-hour trip of 18.75 miles that only cost 25¢.

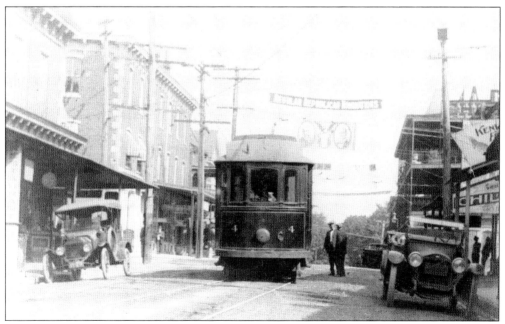

UPTOWN BUSINESS DISTRICT. In 1923, the West Chester Street Railway took over the West Chester, Kennett and Wilmington Electric Railway Company's line to West Grove, with through service beginning in 1924. Note the 1916 presidential banner in the background reading Regular Republican Nominations (Charles Evans Hughes and Charles Fairbanks).

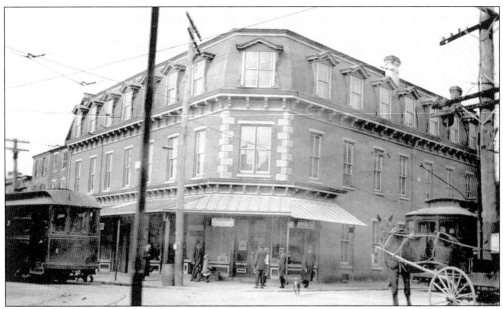

UNICORN BLOCK AND TROLLEYS. Here are Kennett Square's two trolley lines in front of the Unicorn Block in 1911. All trolley service to Kennett Square was discontinued on November 30, 1929. The photographer of these postcards, which are extremely rare, is unknown. Note the awning on the middle window, which is missing on the postcard above. For over 100 years, this intersection was the core of Kennett Square's commercial district. (Courtesy of Dolores I. Rowe.)

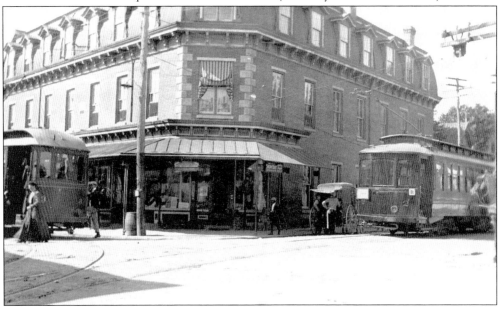

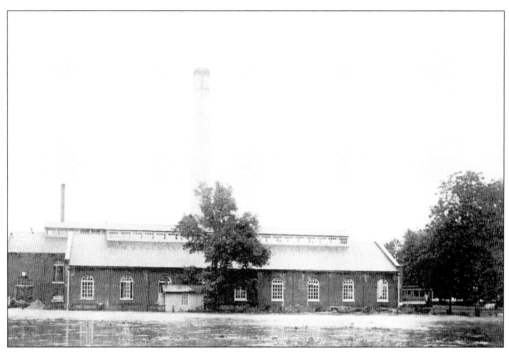

TROLLEY BARN. This is a pre-1909 view of the old trolley barn during a flood along the Red Clay Creek. The trolley barn is still standing, located on East Birch Street.

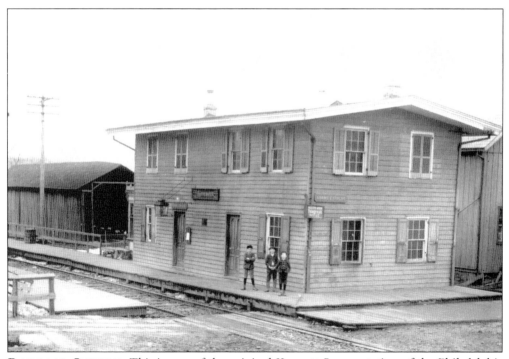

RAILROAD STATION. This image of the original Kennett Square station of the Philadelphia and Baltimore Central Railroad is taken from a glass lantern slide. The railroad came to town in 1859 and contributed to its growth and prosperity.

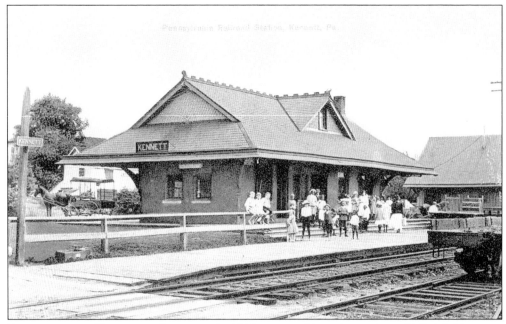

PENNSYLVANIA RAILROAD STATION. In 1910, one could catch a train to Philadelphia every hour, but by 1948, passenger service was discontinued. The passenger station was demolished in 1949, and freight service was stopped in 1963.

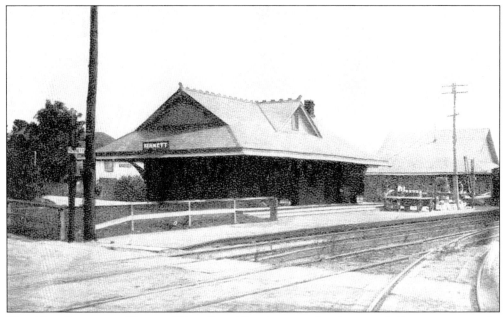

THE OLD RAILROAD DEPOT. The railroad line is now privately owned. For many years, the freight station was leased to the borough of Kennett Square for use as the Kennett Square History Station and Underground Railroad Museum.

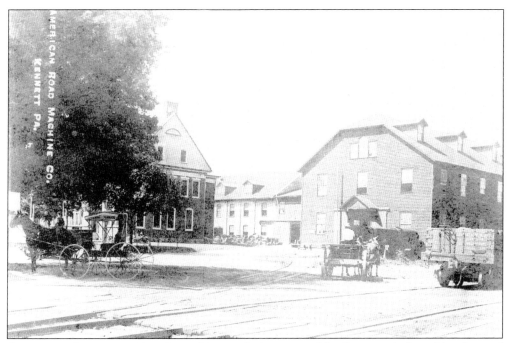

AMERICAN ROADS. In 1877, Samuel Pennock, inventor of the first practical machine for road construction and repair, founded the S. Pennock and Sons Company. It was located on East State and Willow Streets. By 1898, the company was organized as the American Road Machine Company and located on South Broad Street.

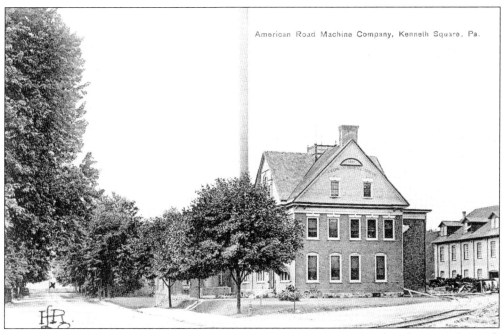

AMERICAN ROAD MACHINE COMPANY, C. 1910. In an 1884 or 1885 advertisement, Pennock claims that his machine "does the work of 50 men, will pay its cost in 4 days." It won "20 First Premiums at State Fairs . . . two machines saved $3400 in 1880 in one town."

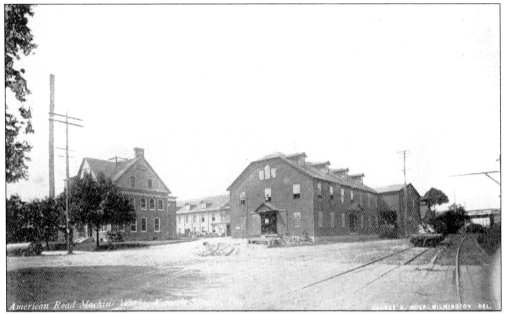

AMERICAN ROAD MACHINE WORKS. This view looks west from Broad Street at the railroad tracks. The company, under various names, remained in operation until 1945. Heavy equipment was produced at the plant during World War II.

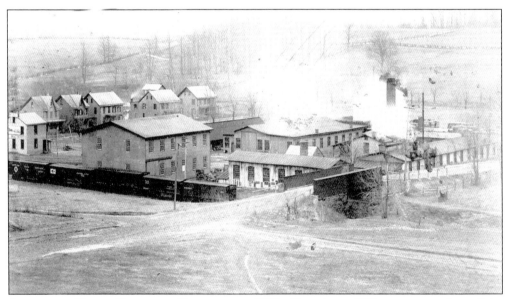

AMERICAN ROAD COMPANY PANORAMA, 1882. Here is an 1882 panorama view of the American Road Machine Company and the Union Street Bridge looking southeast from the tower of the public school building. Today the high school is located on the hill beyond the machine works.

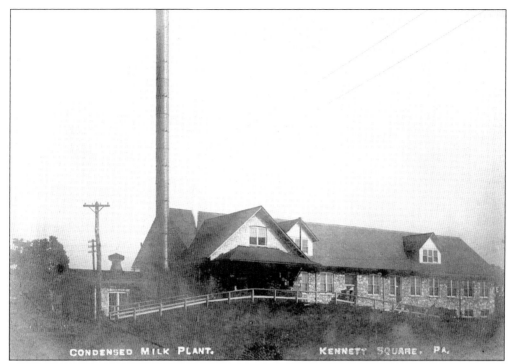

CREAMERY. The Eastern Condensed Milk Company was organized on October 1, 1902, and began operating on June 10, 1903. Italian workmen did the masonry work for the new building. The structure was built and equipped for $60,000 and still stands on East Birch Street.

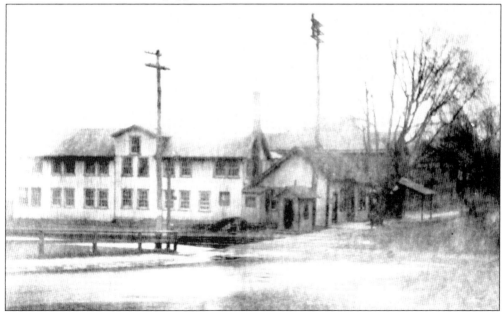

PHILIPS-BRINTON CORPORATION. The company was chartered in 1915 and was owned by Edwin S. Philips and William C. Brinton Jr. In 1920, the company was reorganized, and the name was changed to the Philbrin Manufacturing Company. They manufactured automobile parts and other appliances, including ignition systems for automobiles and gasoline locomotives.

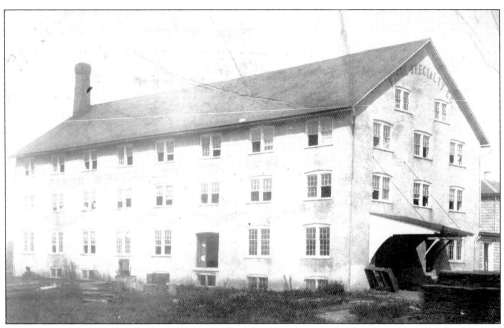

FIBRE SPECIALTY COMPANY. In 1898, Elwood and Israel Marshall built a plant in Kennett Square to make commercial trunks, suitcases, and special cases using a comparatively new material—hard vulcanized fiber (laminated paper). The building burned in 1902, and a new plant was built in 1905 under the name of Fibre Specialty Company Manufacturing. It was located by the railroad tracks on the west side of town. In 1914, it became part of the National Vulcanized Fibre Company (NVF). In 1925, the plant began manufacturing a laminated Bakelite product that was called Phenolite. By 1955, over 400 people were employed by the company. At that time, it was known simply as NVF. The plant was sold in 2005 and is now closed. These postcards date from before 1910.

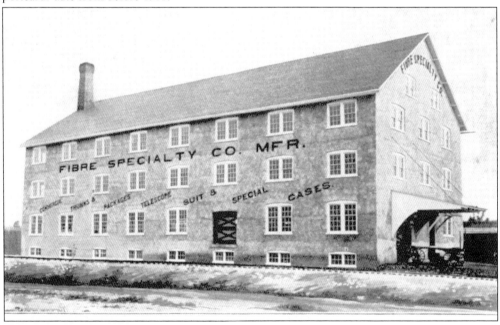

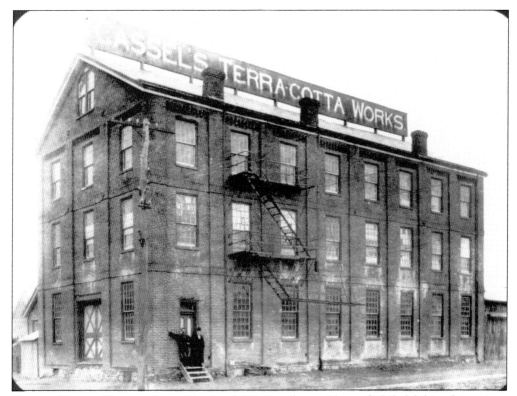

TERRA COTTA WORKS. Started by Jacob W. Cassel, a resident of Philadelphia, this unique establishment was located on the northwest corner of Meredith and Cedar Streets. Originally he leased property from the Vulcan Road Machine Works for five years beginning in 1893. The company made fancy tiling for fireplaces, decorative pottery, and fancy earthenware. In 1909, a new building, known as the Four Story, was built on ground purchased by J. Bancroft Swayne and Michael Grady. In 1910, Cassel Terra Cotta bought out the Keystone Terra Cotta Works. The brick structure burned to the ground on September 16, 1916, due to a fire in the elevator shaft.

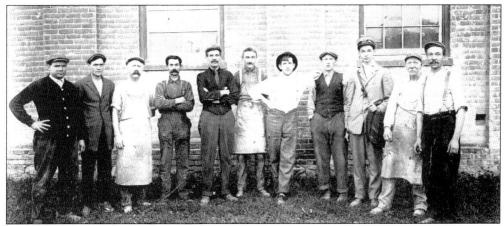

TERRA COTTA WORKS EMPLOYEES, 1910. Pictured from left to right are Mr. Walsh, Herbert Walter Patchell, Mr. Griffin, Price L. Ford (engineer), Al Davis, George W. Fritz, J. Percy Worrall, Roy Levenite, Harvey Pontzler, Charles A. Dean, and Irey J. "Harry" Fritz.

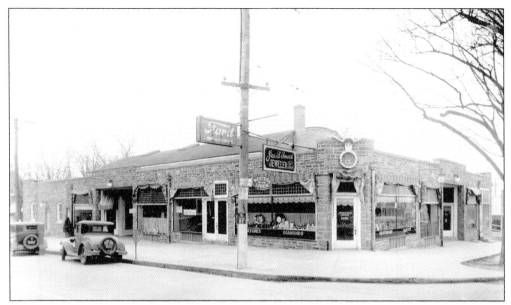

AMERICAN LEGION BUILDING, C. 1928. At the corner is Joseph S. Smock's jewelry shop, which was established in 1926. He sold fine diamonds and mountings, Hamilton and Elgin watches, silverware, and glassware, as well as doing watch and clock repairing. During World War II, there were automobile shows and church league basketball games in the legion building. For many years, the Kennett Square Post Office was located in this building.

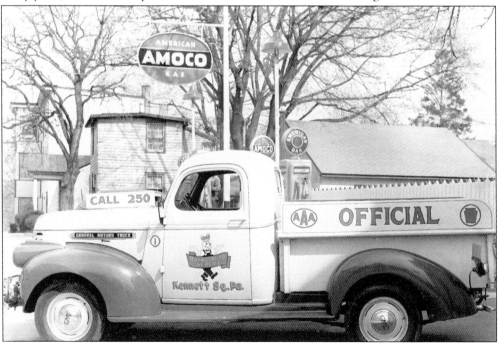

AMOCO SERVICE STATION. The service station was owned by Jacob Noznesky and was located at 201 South Union Street. In 1907, Noznesky established a scrap business and by 1925 was also operating the Royal Garage, located at 115–117 South Union Street. Note the Taylor Building in the background, where many of the local physicians had their offices.

Three
Cultural and Educational Institutions

A Souvenir of Kennett Square. This generic postcard of small Victorian images in the letters dates from 1916 and was published by I. Stern of New York.

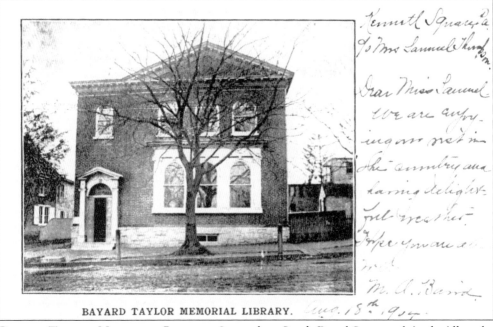

BAYARD TAYLOR MEMORIAL LIBRARY. Located on South Broad Street and Apple Alley, the library was chartered in 1895 and governed by nine founding directors. The postcard, with the postal date of August 18, 1904, is the oldest view postcard known to exist from Kennett Square.

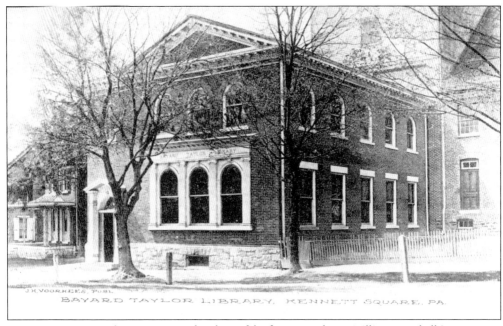

FIRST LIBRARIAN. Alice B. Swayne, daughter of the famous sculptor William Marshall Swayne, was the first librarian from 1896 to 1918. The firemen's auditorium can be seen in the background.

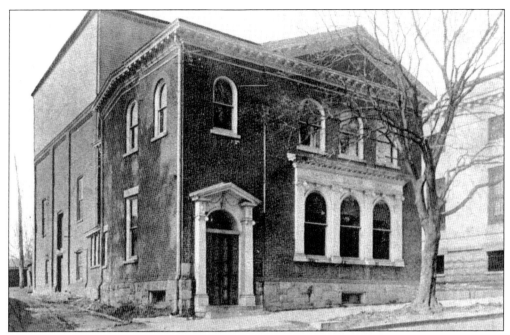

BAYARD TAYLOR MEMORIAL LIBRARY, C. 1920. The rear of the Kennett National Bank and Trust Company can be seen to the right. The library director at that time was Florence Nightingale Cleaver, from 1918 to 1930.

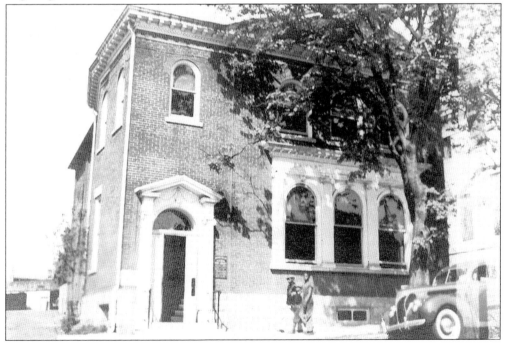

BAYARD TAYLOR MEMORIAL LIBRARY, 1940. This view of the library was taken in the 1940s when Roberta Cann Cole Ficcio was librarian. She was the longest serving library director—1936 through 1969. The building was torn down in the late 1960s to make way for an expansion of the bank. (Courtesy of Dolores I. Rowe.)

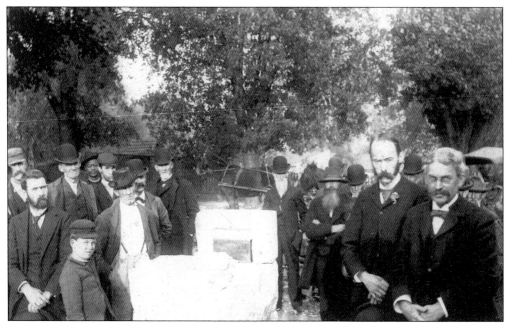

LIBRARY CORNERSTONE. The laying of the library cornerstone took place on October 26, 1895. The bearded gentleman on the far left is D. Duer Philips. The two gentlemen pictured on the far right are M. Pennock Bernard, on the left, and William W. Polk. These three gentlemen were founding members of the library.

WOMEN'S NEW CENTURY CLUB OF KENNETT SQUARE. Located at Center and West Cypress Streets, the club was formed in 1897, and the building shown was built in 1927. The club sponsored or supported many worthwhile community activities, including the Girl Scouts, the library, and the Community Nurse Association. In 1947, dances for teenagers were held every two weeks. Masonic Lodge 475 now uses the building.

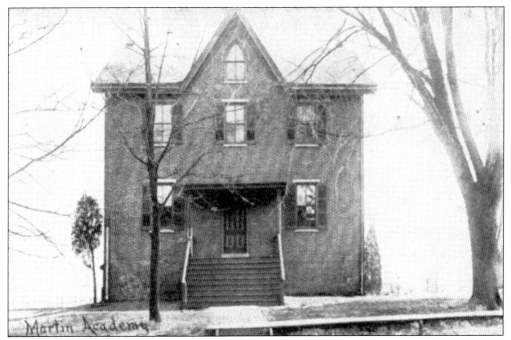

MARTIN ACADEMY. The academy was located on East State Street and established by Samuel Martin (1802–1880) in 1875 as a preparatory school. It was first called the Kennett Academy. Because of declining enrollment, the school was closed in 1910 and used by the public school for the third and fourth grades.

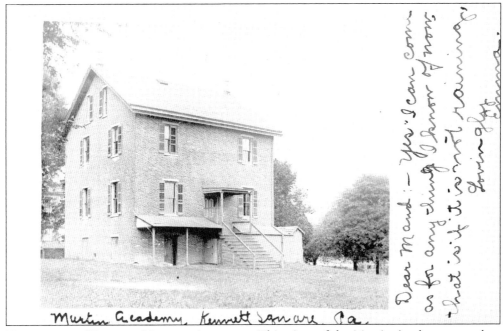

NORTHWARD VIEW OF MARTIN ACADEMY. This view of the Martin Academy was taken from Apple Alley and looks north toward East State Street. In 1918, the building was used as a hospital during the influenza epidemic. (Courtesy of Dolores I. Rowe.)

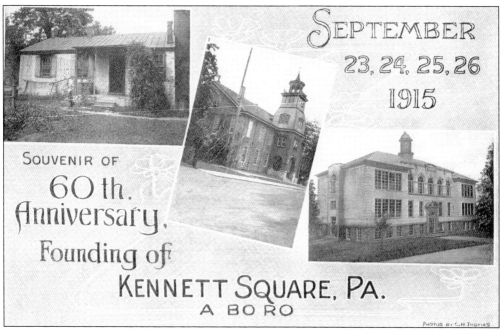

KENNETT PUBLIC SCHOOLS. The first public school is shown in this souvenir postcard produced by C. H. Thomas in 1915 for the 60th anniversary of the founding of Kennett Square. It was located on the southeast corner of West Cypress Street and Sycamore Alley. Also pictured are the elementary and high school buildings.

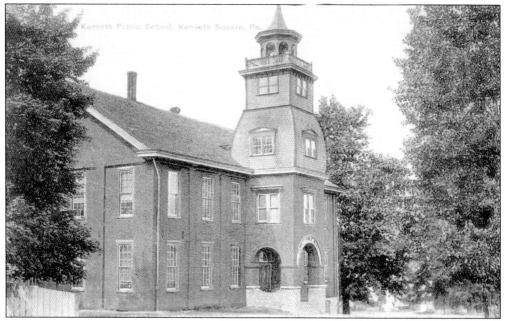

SECOND PUBLIC SCHOOL. The second public school in the borough was built in 1869 with four rooms. The first principal was Isabella Shortlidge, who taught the older students. Maggie Mercer and Emmarene Walton were her assistants.

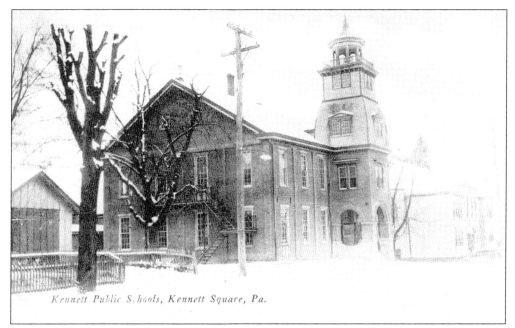

THEODORE YARNALL. Here is a rare postcard published by Theodore Yarnall about 1922 of the school in wintertime. To the right is the newly erected high school building. (Courtesy of Dolores I. Rowe.)

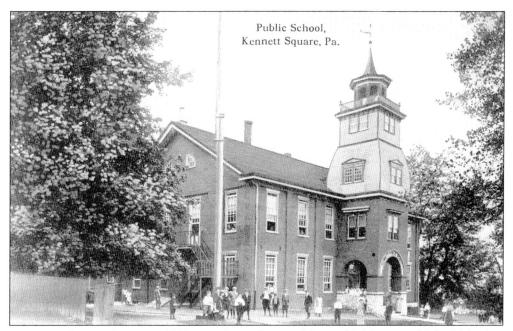

KENNETT PUBLIC SCHOOL, 1920s. Louis Kaufman and Sons of Baltimore published this view of the public school during the 1920s.

MULBERRY STREET PUBLIC SCHOOL. Samuel J. Parker and Son published this postcard of the Mulberry Street Public School about 1910. Samuel J. Parker produced some of the most beautiful postcards in Chester County before 1912. These postcards were printed in Germany.

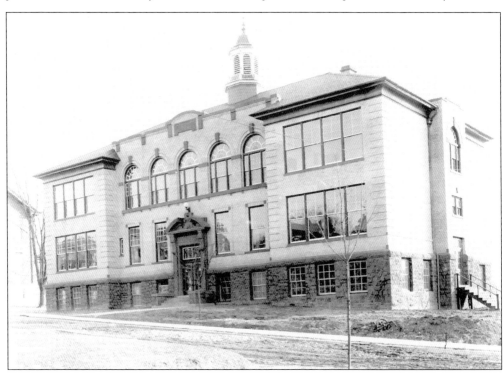

THE HIGH SCHOOL. The high school was built in 1915 and was located on Mulberry Street, just west of the elementary school, which can be seen on the left.

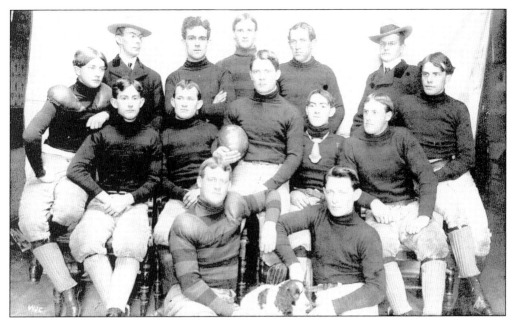

FOOTBALL TEAM, 1901. This rare photograph by William J. Chambers of Kennett Square shows the 1901 Kennett Square High School football team and mascot. That year, they were the Chester County champions. (Courtesy of Dolores I. Rowe.)

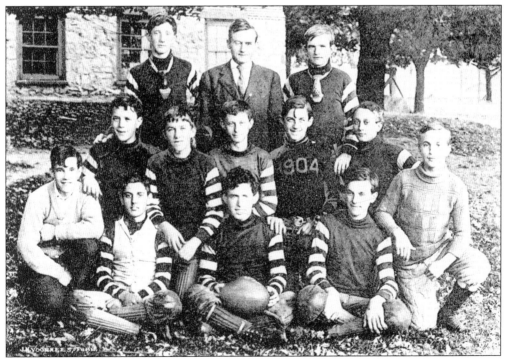

FOOTBALL TEAM, 1904. This Albertype postcard shows the 1904 Kennett High School football team. Leroy Mercer (1888–1957), Kennett Square's most famous football player, is a member of the College Football Hall of Fame in South Bend, Indiana. (Courtesy of Dolores I. Rowe.)

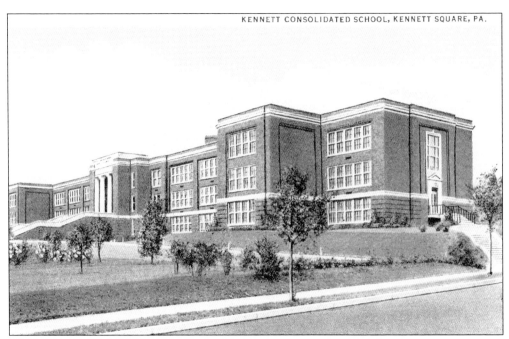

LARGEST CONSOLIDATED SCHOOL. At the suggestion of Pierre S. du Pont, a local philanthropist, three municipalities (the borough of Kennett Square and Kennett and New Garden Townships) came together to build the largest consolidated school in the United States at the time. The building was dedicated on December 4, 1931.

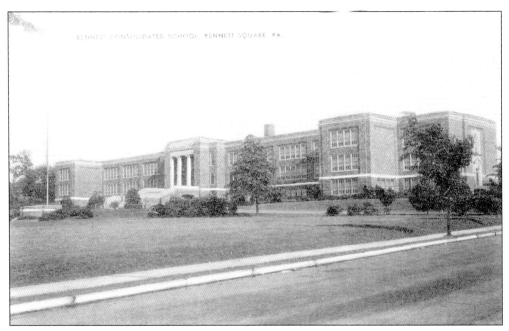

KENNETT CONSOLIDATED HIGH SCHOOL. J. P. Walmer produced this postcard of the new high school in the 1930s. At its opening, there were between 1,600 and 1,800 students enrolled. Originally the new consolidated school housed students in grades 1 through 12.

Four

Religious Institutions

A Message Within a Message. This generic "Greetings" postcard by an unknown publisher dates from the second decade of the 20th century. A message was written and enclosed in the small envelope attached to the front.

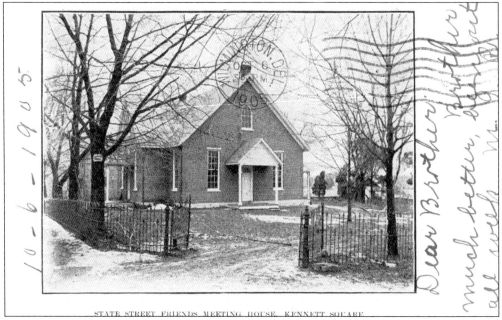

STATE STREET FRIENDS MEETINGHOUSE. State Street Friends is the oldest place of worship in Kennett Square. It was a Hicksite meeting and very strongly opposed to slavery. The meetinghouse was built on land owned by Robert Lamborn, who at the time, had a reputation for drunkenness and disorder.

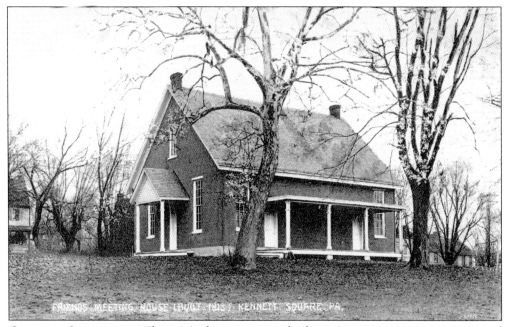

ORIGINAL STRUCTURE. The original structure was built on August 17, 1814, among a stand of Lombardy poplar trees.

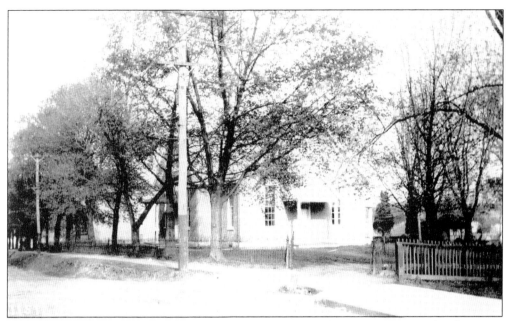

RECONSTRUCTION. In 1873, the original meetinghouse (built in 1814) was razed and a newer house erected, with the first meeting held in the autumn. The main entrance was from the north. In the mid-1950s, the land was sold to the Bayard Taylor Memorial Library, and a new meetinghouse was erected on West Sickles Street. This real-photo postcard dates from 1909. (Courtesy of Dolores I. Rowe.)

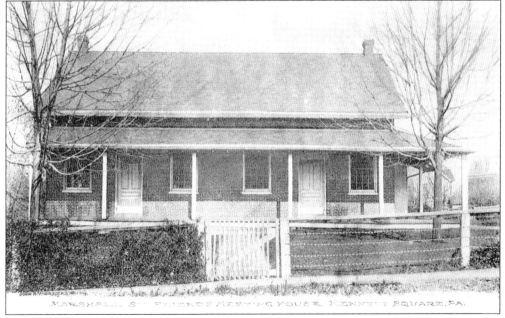

ORTHODOX FRIENDS MEETINGHOUSE. In 1881, a lot was purchased on the corner of East Cypress and Marshall Streets for the purpose of erecting an Orthodox Friends meetinghouse. Henry C. White was hired to build the new structure, which opened for worship in 1882. In 1938, the meetinghouse was sold, and today the building is used as an orthodontics office.

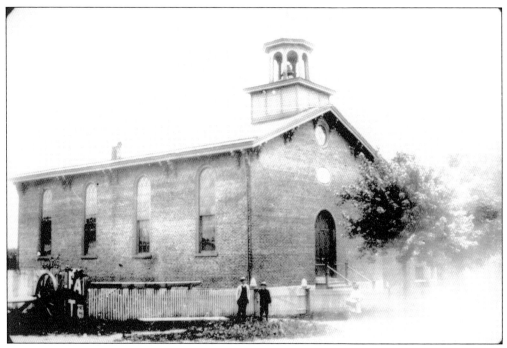

PRESBYTERIAN CHURCH. This church was organized in the old borough hall on November 1, 1862. During 1862, the Reverend John Scott Gilmour, the first pastor, arrived in Kennett Square, and on May 18, 1862, the first sermon was held in borough hall. Reverend Gilmour also organized the Sunday school. Late in 1865, a building was erected for $6,200. The original structure was in place until 1909.

CHURCH GROUPS. The church also organized the following groups: in the 1880s, the Women's Foreign Missionary Society, which was reorganized in the 1890s as the Women's Home and Foreign Missionary Society; Christian Endeavor in 1889; Junior and Intermediate Societies in 1922; Men's League in 1926; and the Boy Scouts in 1928.

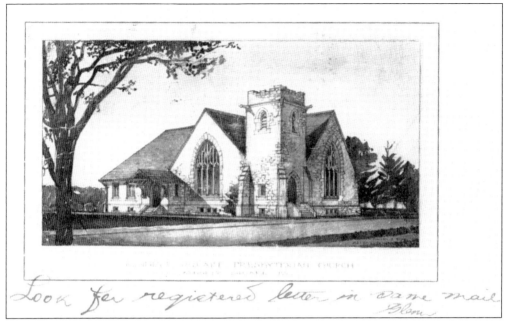

NEW PRESBYTERIAN CHURCH. Pictured above is an architectural rendering of the present church, erected in 1909. The cornerstone was placed on June 26, 1909, and the church was dedicated on January 24, 1910.

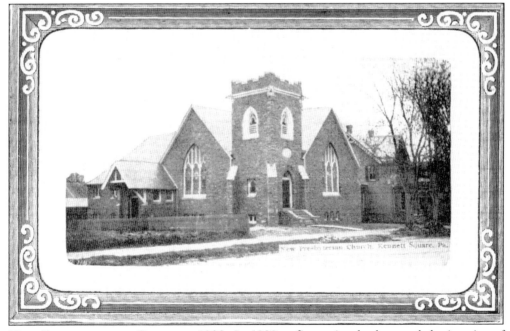

NEW PRESBYTERIAN CHURCH, 1928. In 1928, a fire seriously damaged the interior of the church and the pipe organ. Many improvements were made during restoration, and an Aeolian-Votey organ was installed for $6,500.

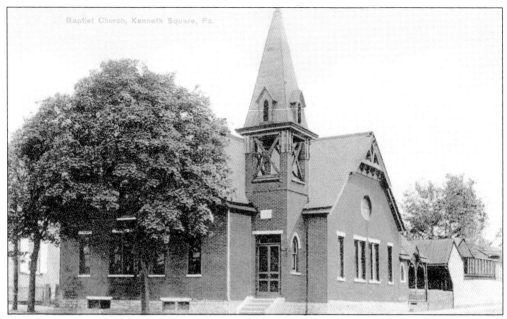

FIRST BAPTIST CHURCH. The Baptist church was organized on December 20, 1882, with 19 members. On January 28, 1883, the Reverend J. M. Lyons was elected the first pastor. On October 22, 1883, a lot was purchased for $845 on the northeast corner of South Union and Cypress Streets. Groundbreaking for the new church was on May 12, 1885, and by October 4, 1885, the building was opened for worship at a total cost of $5,649.25. The church charter was obtained on March 1, 1886. By October 1, 1887, there were 55 members.

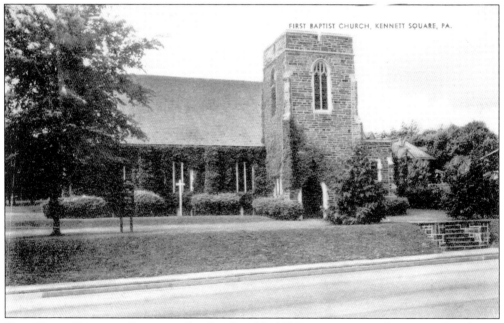

NEW FIRST BAPTIST CHURCH. On October 25, 1925, a cornerstone for a new church was laid, and on December 5, 1926, the first sermon was held. The new church is located on West State Street at Garfield Street.

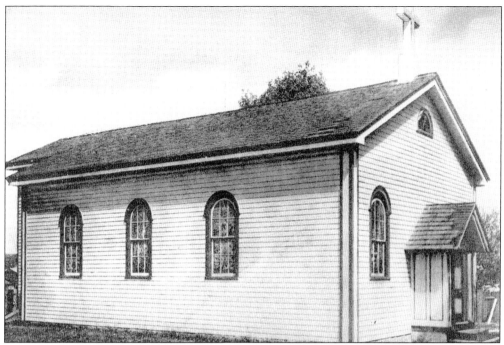

CATHOLIC CHURCH. During the 1860s, Irish families moved to Kennett to work at the S. and M. Pennock Company. A mission was established to serve their spiritual needs in 1868. In 1869, Rev. John Wall organized a fund-raising drive for the building of a church on West South Street on land donated by Samuel Sinclair.

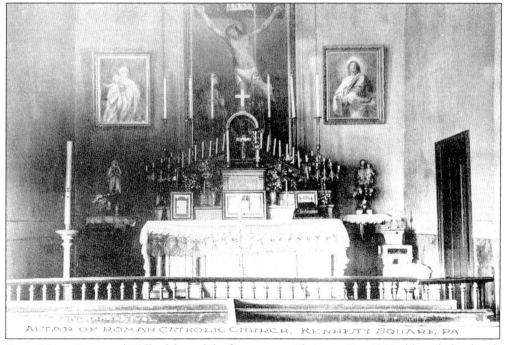

FIRST MASS. Reverend Wall celebrated the first mass on Christmas Day 1869, although the church was not completed and dedicated until 1872. Pictured above is a scarce postcard of the altar.

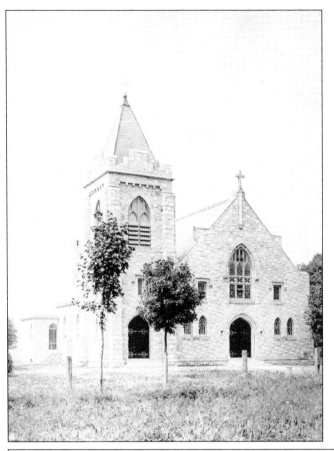

DEDICATION. On August 9, 1908, a newly built church on the southwest corner of Meredith and Cypress Streets was dedicated. The new church facility was made of Avondale limestone in the Gothic style, and its stained-glass windows were made in Munich, Germany. Thomas Grady was the builder, with Corcoran Brothers of West Chester in charge of the stonework. The rectory was also completed in 1908. The school was opened in 1922 in the building that is now the convent, and a new school was constructed in 1927 under the pastorate of Rev. Austin C. Grady.

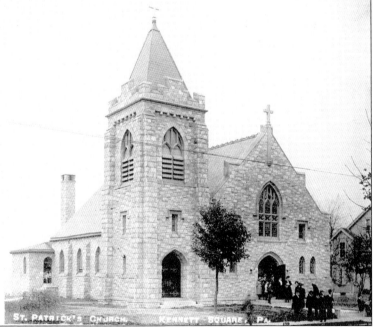

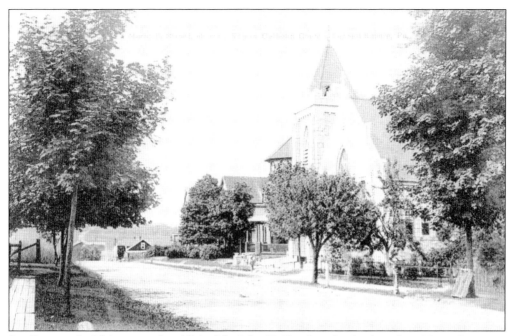

ST. PATRICK'S. This postcard, published for John H. Voorhees by the American News Company of New York about 1910, shows St. Patrick's Roman Catholic Church and the houses along Meredith Street.

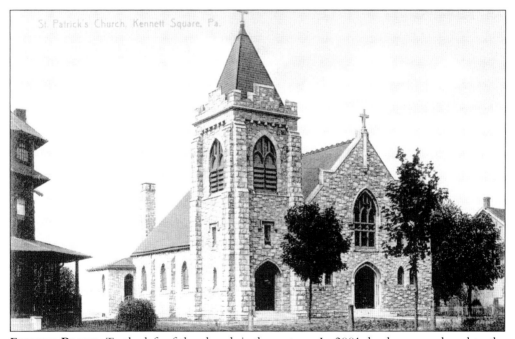

FUTURE PLANS. To the left of the church is the rectory. In 2001, land was purchased to the rear of the church on Lafayette Street. Plans are to enlarge the church and build an educational center and school gymnasium.

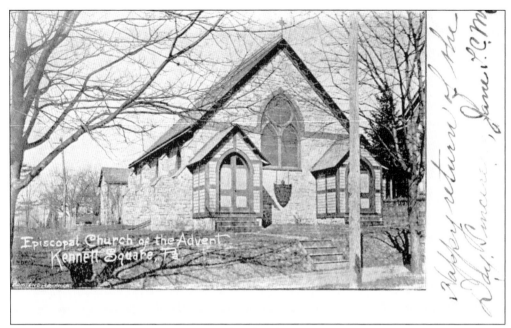

EPISCOPAL CHURCH OF THE ADVENT. This church was incorporated on May 1, 1882, and the cornerstone laid on May 17, 1885, with the Rev. William Bacon Stevens officiating. The church was consecrated on May 14, 1886. One of the windows in the church is a Bayard Taylor memorial.

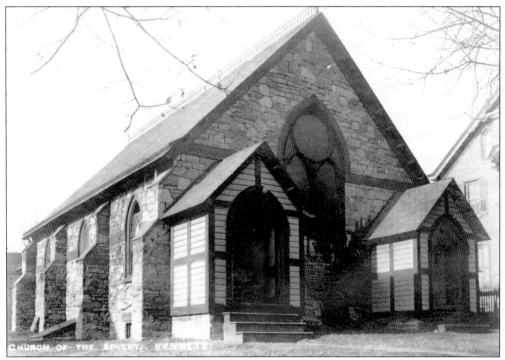

ST. MICHAEL'S LUTHERAN CHURCH, 1958. In February 1958, the original church on South Broad Street was purchased by St. Michael's Lutheran Church, which was organized April 5, 1959. This real-photo postcard dates from about 1909, when it was the Church of the Advent.

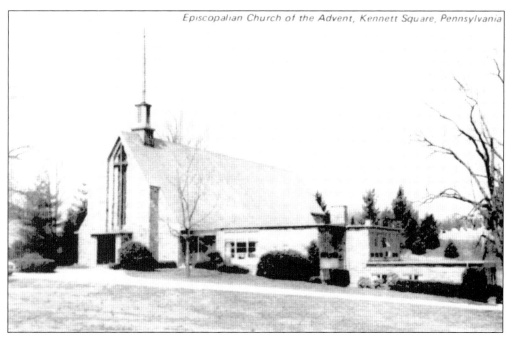

NEW EPISCOPALIAN CHURCH OF THE ADVENT. On November 4, 1956, the cornerstone of the new church on North Union Street was laid, and on June 23, 1957, the first services were held.

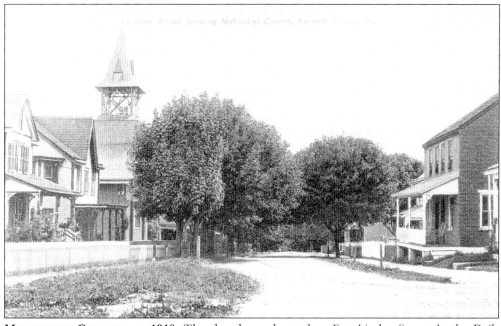

METHODIST CHURCH, C. 1910. The church was located on East Linden Street. In the *Daily Local News* of September 8, 1906, the church advertised the 23rd semiannual tour of Lyman H. Howe's "Lifeorama with unique travel and scientific subjects, clean humor." Twenty-five adults and 154 children attended.

FRIENDS HOME. Built in 1843 on West State Street by Samuel Martin, this building started out as the Kennett Square Female Seminary with 40 pupils. In 1856, Martin sold the school to Dr. Elisha Gatchell, who renamed it Eaton Academy. In 1865, after several directors, the school became well known as an outstanding boarding school for girls under the leadership of Evan T. Swayne. The school closed in 1877 and was used as a dwelling until 1901, when it was purchased by the Western Quarterly Meeting of Friends and turned into the Friends Home. The building still serves in this capacity today. The mid-1930s Chester Thomas real-photo postcard below shows an addition that was added at a later date. (Courtesy of Dolores I. Rowe.)

Five

NEIGHBORHOODS AND STREETSCAPES

GREETINGS FROM KENNETT SQUARE. This generic postcard dates from 1908.

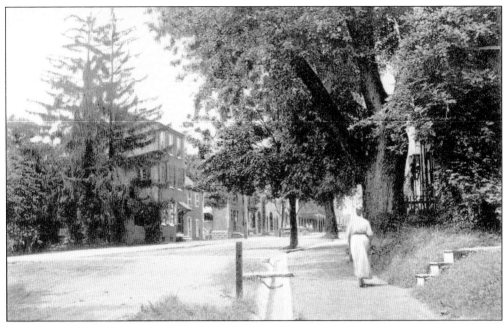

EAST STATE STREET. This serene postcard shows the south side of East State Street looking west from Church Alley toward the corner of Broad Street. Up the street the old bank building and the firemen's auditorium can be seen.

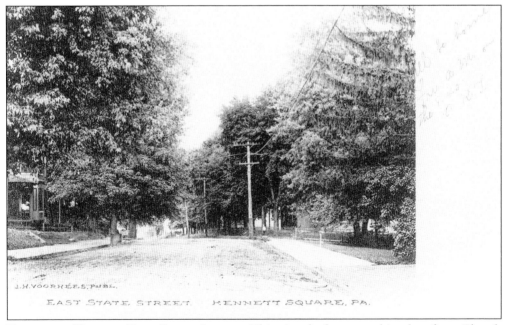

EASTWARD VIEW OF EAST STATE STREET. This view looks east and is taken from Church Alley. The plot of land on the right was the location of the State Street Friends meetinghouse. Today the Bayard Taylor Memorial Library is located on this spot.

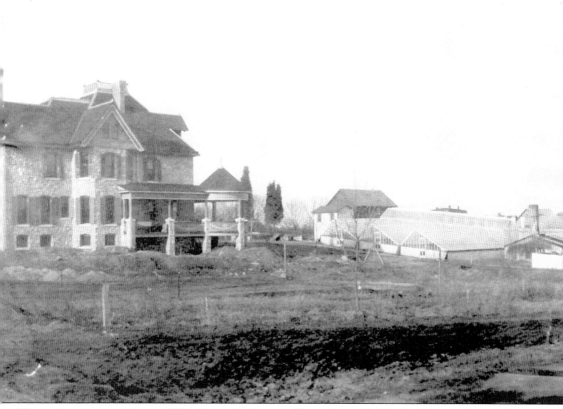

Hicks-Schmaltz House. This Victorian home still stands at 120 Marshall Street. Although built by Harry Hicks, it is locally known as the Schmaltz house after the family who owned it in the early 1900s. H. Schmaltz and Company, a hardware, tinsmith, and plumbing business, began business around 1904 at 101 East State Street. To the right of the house are the greenhouses that were owned by Hicks. Hicks and William Swayne, also a florist, discussed the possibility of growing mushrooms below the greenhouse benches. Swayne obtained some spawn, and after a trial growing period, both Swayne and Hicks decided to try cultivating mushrooms. Hicks started the first mushroom house on Willow Street and Apple Alley, but it was not a success. In 1882, Swayne began to cultivate mushrooms under greenhouse benches, and in 1896, he constructed the first successful mushroom house. The building was designed especially for mushroom growing with controlled temperature and ventilation. His son, J. Bancroft Swayne, eventually took over the business and made it commercially viable. The house is now used as offices for the borough of Kennett Square.

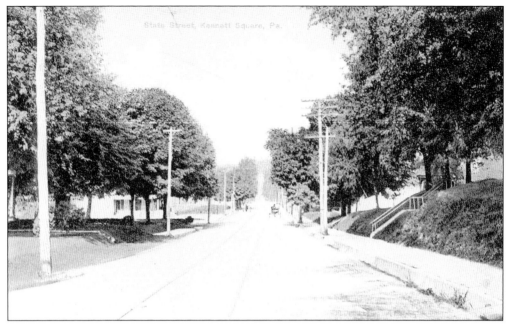

WEST STATE STREET. Pictured here is a view of West State Street looking west from Center Street about 1910. The building to the middle right was the Mohican Garage, while the Kuzo and Grieco funeral home is now located on the left side.

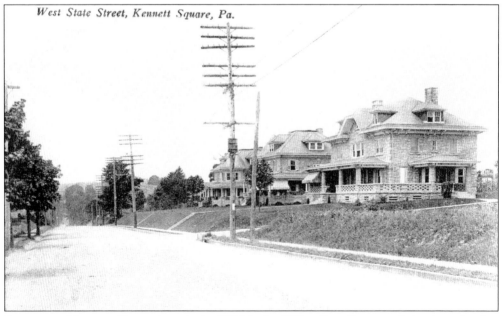

SCARLETT HOUSES. Shown here is the 500 block of West State Street and the three Scarlett houses. The houses were the homes of, from left to right, Walter (521), George (511), and Robert (503) Scarlett. George was a Pennsylvania state senator and a former borough burgess.

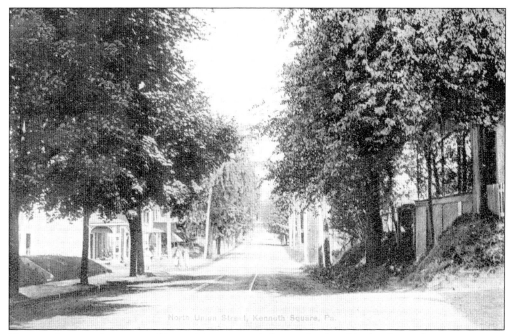

NORTH UNION STREET. This *c.* 1910 postcard shows the 200 block of North Union Street. Note the trolley tracks leading to Unionville. All the houses on the left side of the street are still standing today.

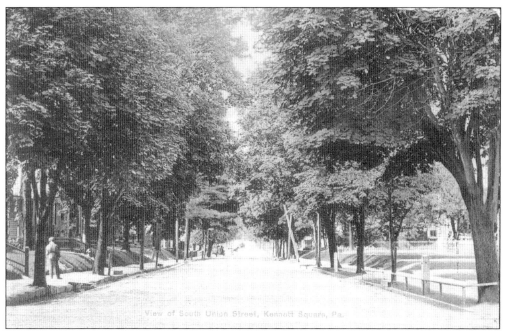

SOUTH UNION STREET. Here is a view of South Union Street about 1910 looking south from Cypress Street. All the homes on both sides of the street are still standing today.

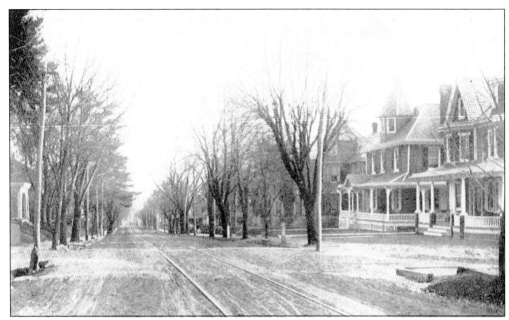

PALMER AND ENTRIKEN HOUSES. Pictured to the far right is the J. Monroe and Frank M. Palmer house, and next door is the Davis W. Entriken house at 200 and 204 South Union Street respectively. Both houses date from 1907 and were built in the Queen Anne style. In the late 1870s, Entriken had a mercantile store in what later became the Chalfant Block. J. Monroe Palmer was a florist who specialized in growing carnations, while Frank was associated with mushrooms (as listed in the 1908 Boyd's directory).

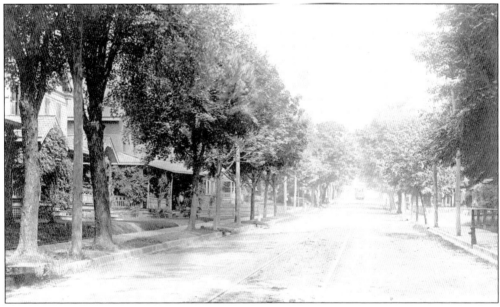

THE SOUTHBOUND TROLLEY. This real-photo postcard shows the homes located on the west side of the 200 block of South Union Street. Farther up the street, at Cypress Street, is the trolley car on its way to Brandywine Springs, Delaware.

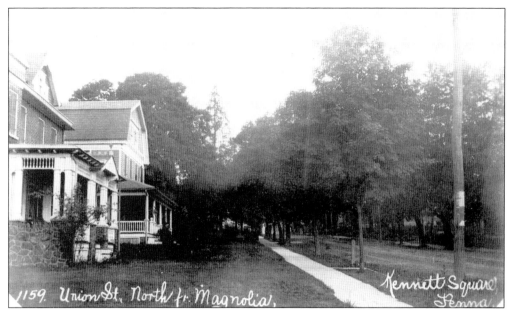

FROM 232 TO 236 SOUTH UNION STREET. This real-photo postcard was published in 1910 by Ed Herbener and shows the homes at 236 and 232–234 South Union Street just north of Magnolia Street.

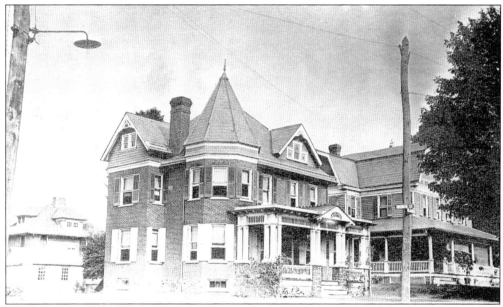

COURSON HOUSE. Located at 236 South Union Street, this house was the home of local pharmacist Harry S. Courson when this real-photo postcard was made. More recently, it was known as the home of the late Sarah Noznesky, whose father Jacob ran the scrap yard in town. Today the house has a high hedge along the Magnolia Street side and large trees and shrubs in the front. The duplex to the right is located at 232–234 South Union Street. (Courtesy of Dolores I. Rowe.)

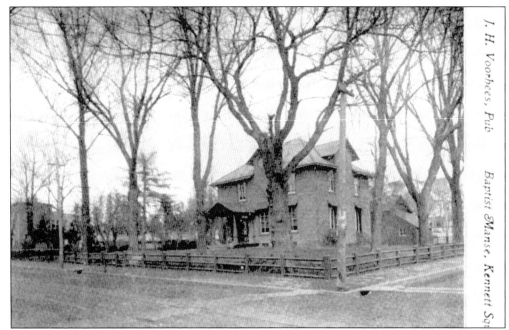

LAMBORN HOUSE. This private mailing card shows the house at 341 South Union Street, which was built by Charles Burleigh Lamborn and Emma Lamborn (née Taylor) about 1880 on land that was once owned by Josiah Jackson. Emma was the sister of Bayard Taylor, and it was at this residence that their mother died in 1890. Charles Lamborn died in 1902, and Emma later moved to Hornblend, her estate on West Sickle Street. At that time, the property was given to the Baptist church and became the Baptist manse. In the 1920s, Erminio Bugliani added stucco to the exterior. To the far left are row houses that were built by Samuel Martin before 1873. In 1926, Bugliani built six townhouses on the vacant lot.

BROAD STREET. This real-photo postcard was published in 1910 and shows the homes in the 100 block of South Broad Street at Cypress Street. In the center background is the Kennett Inn, this being the only known image of the inn from this period.

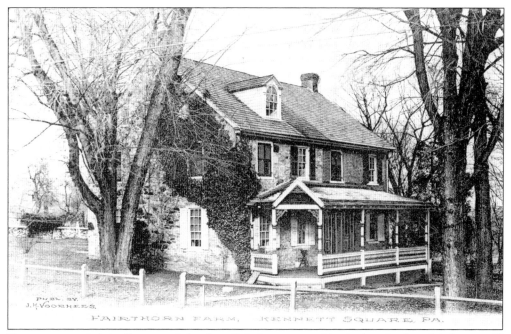

FAIRTHORN. Originally part of the farm Fairthorn owned by Joshua Taylor, this home still stands at 315 North Union Street. The stone section, built around 1800, is two rooms deep and is probably an original William Penn plan. There is now a large opening between the two original rooms. There are two corner fireplaces that use one chimney on the west end.

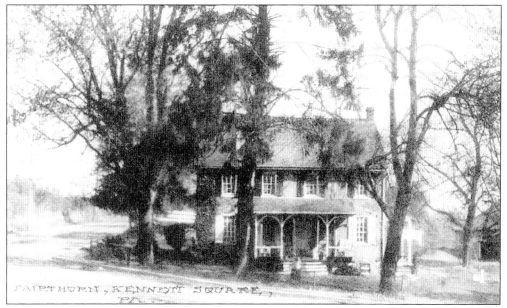

OLDEST HOME. This home is the oldest house in Kennett's historic district and retains much of its original material. The home has been known as Fairthorn since the 1866 publication of Bayard Taylor's *The Story of Kennett*. In Taylor's novel, the character Sally Fairthorn was loosely based on Sarah Taylor, aunt of Bayard Taylor and daughter of John Taylor, who owned the house.

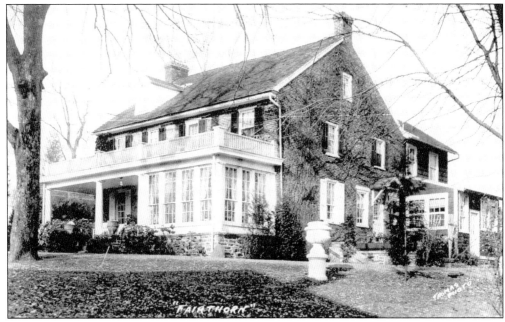

FAIRTHORN AROUND THE 1930S. This real-photo postcard of Fairthorn dates from the 1930s and was taken by Chester Thomas, a local photographer and postcard publisher.

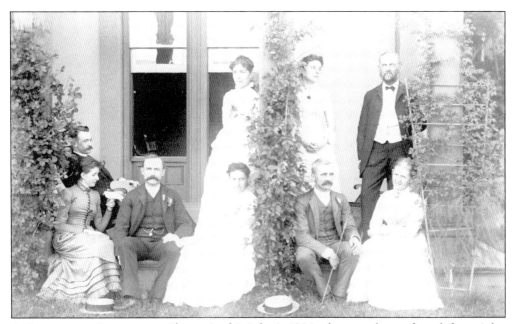

A LAWNFIELD GATHERING. Shown in this July 6, 1884, photograph are, from left to right, (seated) James Chalfant, Mrs. White, Howard Pusey, Rosalie Pusey (née Sickels), Mr. Passmore, and Ellen Taylor (sister of Lydian Sickels [née Taylor], Theophilus Ellsworth Sickels's deceased wife); (standing) Miss L. Stewart, another Stewart, and Theophilus Ellsworth Sickels.

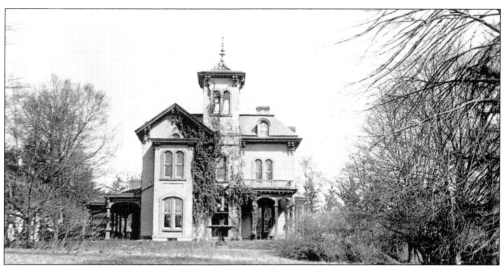

LAWNFIELD. The *c.* 1920 real-photo postcard above shows Lawnfield, the home of Theophilus Ellsworth Sickels (1821–1885). Sickels was a prominent civil engineer who first came to Kennett Square while working for the Baltimore Central Railroad. During his stays in Kennett Square, he met and later married Lydian Taylor (1831–1876), daughter of Joshua and Mary Taylor (who lived at Fairthorn). Sickels was also the chief civil engineer for the Union Pacific Railroad. Although constantly away from home, he took an active role in local affairs and erected the Unicorn Block in 1877. Along with Franklin Taylor, he was responsible for bringing the first printing press to Kennett Square. Taylor then started Kennett's first newspaper, the *Kennett Free Press*. The last owners to live in Lawnfield as a private residence were state senator and Mrs. George B. Scarlett, who purchased Lawnfield in 1934. In 1954, the Presbyterian Homes of Central Pennsylvania purchased the property. The home, located on West Sickle Street, was demolished in early October 1981. Sickels is pictured in the photograph below.

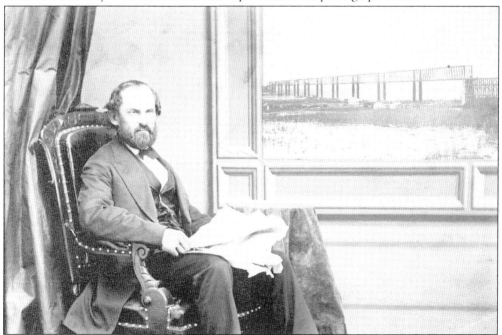

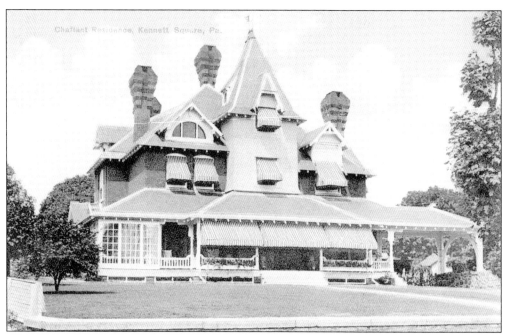

HOUSE AT 220 NORTH UNION STREET. This magnificent Queen Anne–style house at 220 North Union Street was designed by the famous Philadelphia architect Frank Furness (1839–1912) and was built for William Chalfant in 1884. Furness, who was influenced by the Romantic revival tradition of the neo-Gothic, had an impact on the theories of Louis Sullivan, the famous Chicago architect.

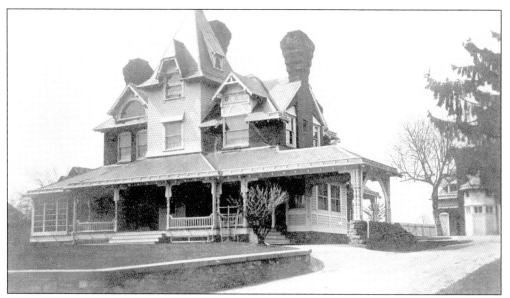

CHALFANT HOUSE. The chimneys on this house are very unusual and are thought to resemble early locomotive smokestacks. To the rear can be seen the carriage house, which has recently been restored. (Courtesy of Dolores I. Rowe.)

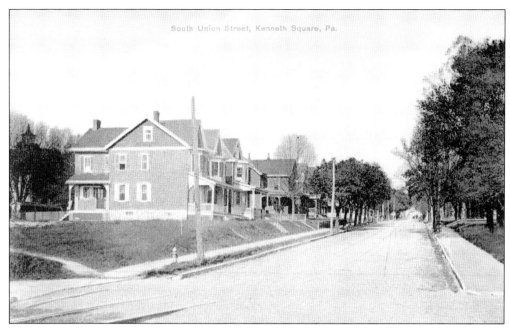

SOUTH UNION STREET. This *c.* 1910 postcard shows the homes on the left side of the 400 block of South Union Street. At the bottom of the picture are Cedar Street and the trolley tracks.

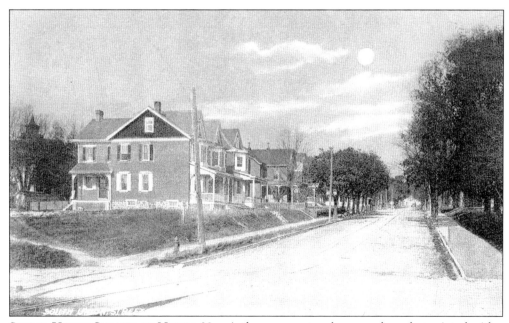

SOUTH UNION STREET AT NIGHT. Here is the same postcard as seen above but printed with a moonlight motif. This was a common practice in the golden age of postcards when companies often doctored existing postcards to create night scenes (see also page 11).

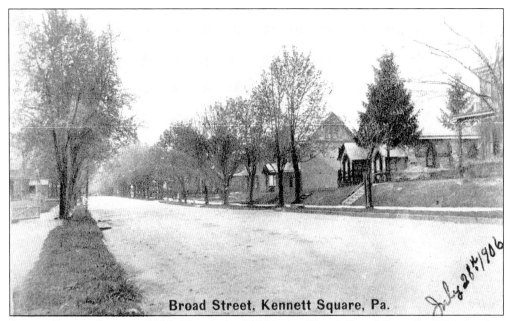

SOUTH BROAD STREET, 1906. Here is the 200 block of South Broad Street in 1906 showing the Episcopal Church of the Advent on the right side of the street.

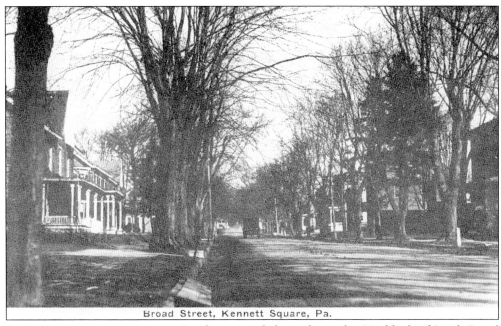

SOUTH BROAD STREET, C. 1922. The postcard above shows the 200 block of South Broad Street looking north from Juniper Street about 1922.

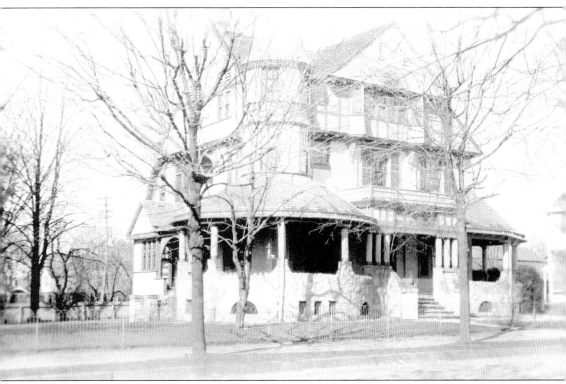

TAFT-GIFFORD HOUSE. This house, located at 332 South Broad Street, was built in 1858 by Thomas Pyle for the Woodward family and was originally Colonial style with two rooms downstairs and two upstairs. It underwent several additions and renovations over time. George W. Taft, president of American Road Machine Company, bought the house and had the first addition constructed. Then, under the direction of a Dutch architect who came through town around 1898, a tower, circular porch, and Victorian gingerbread were added. In 1918, the house was sold to Dr. U. Grant Gifford, who served as a doctor in Avondale and Kennett Square. He was the first cardiologist at the Chester County Hospital. Gifford married Taft's daughter, Clara. Afterward he added an examination room to the house for his practice and a laboratory for her. This house has many unusual architectural features, including a recessed porch on the second floor, a gallery above the main entrance, a variety of window styles and sizes, and gambrel and hip roofs.

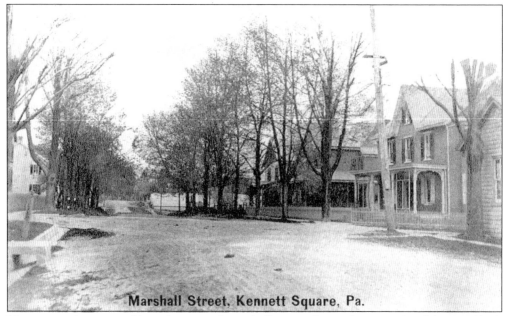

MARSHALL STREET. This early view of Marshall Street shows the east side of the 200 block about 1906. The house on the right is located at 221 Marshall Street.

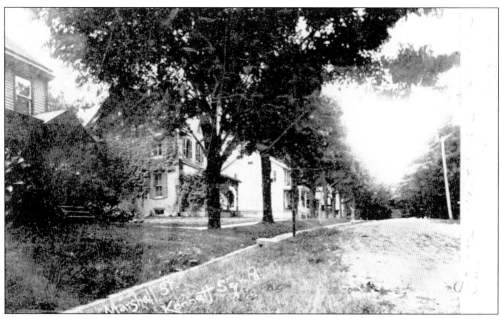

MARSHALL STREET, 1906. This early view of Marshall Street shows the west side of the 300 block about 1906 looking north. The houses are, from the far left, 312, 308, and 300 Marshall Street.

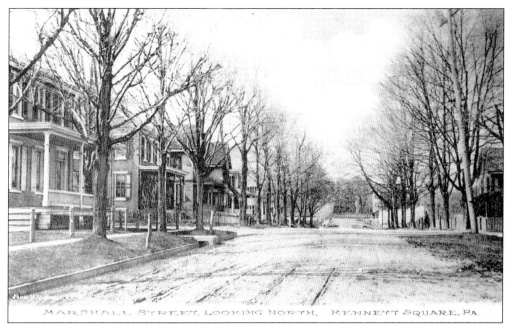

NORTHWARD VIEW OF MARSHALL STREET. This view of Marshall Street looks north toward Cypress Street and the State Street Friends meetinghouse cemetery. In the foreground is part of the 300 block, with the 200 block in the background.

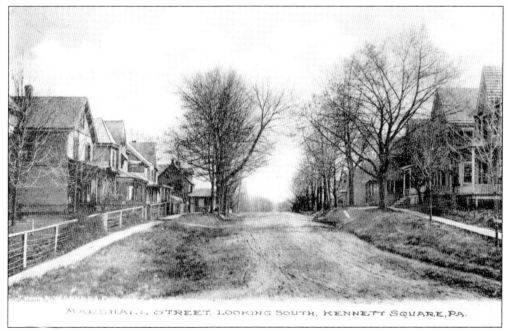

MARSHALL STREET, 1908. This rare 1908 postcard of Marshall Street looks south from Cypress Street. It was published by John H. Voorhees and printed by the Albertype Company. Albertype postcards were printed in black-and-white and hand-colored versions, although, to date, no hand-colored version of this postcard has been found.

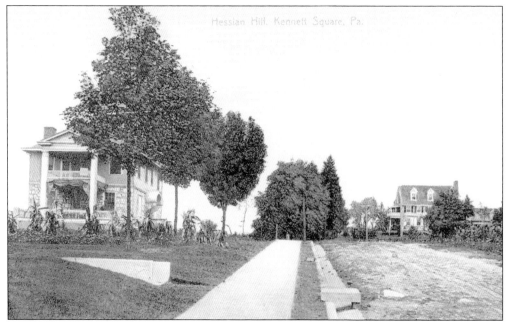

HESSIAN HILL. This postcard shows the house at 228 Garfield Street on the left and the house at 217 West Sickle Street on the right (known as Hornblend, the home of Emma Lamborn [née Taylor], the sister of Bayard Taylor). This section of Kennett Square is known as Hessian Hill because on the evening prior to the Battle of Brandywine, September 11, 1777, Kennett Square was occupied by British troops. The German mercenaries, or Hessians, occupied the hilly area behind what is now the Friends Home, while the British regular troops occupied the hill on the opposite side of town where the Kennett High School now sits.

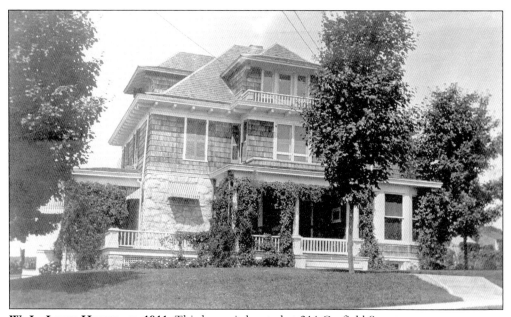

W. L. LANG HOUSE, C. 1911. This home is located at 214 Garfield Street.

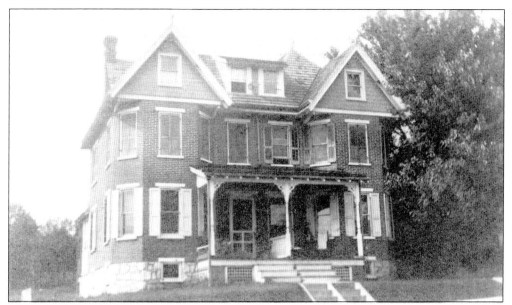

MULBERRY STREET. This real-photo postcard shows the two-and-half-story brick duplex Queen Anne– and Stick-style homes located at 141 and 143 West Mulberry Street. They date from the 1890s. (Courtesy of Dolores I. Rowe.)

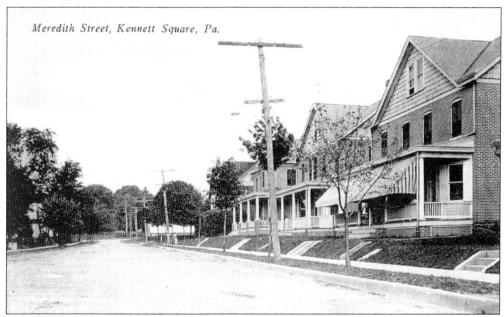

MEREDITH STREET. This postcard shows the homes located in the 200 block of Meredith Street. St. Patrick's Roman Catholic Church is located directly across the street to the left.

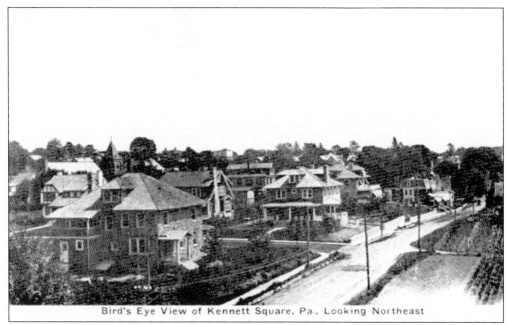

A BIRD'S-EYE VIEW. Taken from the west end of Magnolia Street, the home in the foreground is located at 234 Lafayette Street. Going north along the east side of Lafayette Street are, from left to right, the homes at 221, 227, and 231. Going east on Magnolia Street are 230 Meredith Street and a double house with a mansard roof at 221–219 Magnolia Street. St. Patrick's steeple is to the left.

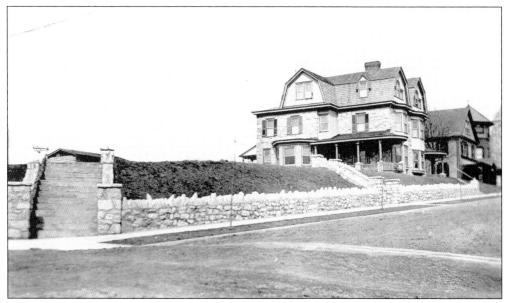

MAGNOLIA AND MEREDITH STREETS. This unusual real-photo postcard shows the northwest corner of Magnolia and Meredith Streets before 1915. The double house at 226–228 Meredith Street that was built about 1905 can be seen. One can also see 222 Meredith Street, the Catholic rectory, and St. Patrick's Roman Catholic Church. The back of the card states, "This is a vacant lot and for sale. What do you think of the stone wall?"

BARNARD HOUSE, 1907. This real-photo postcard dates from 1907 and shows the Barnard house located at 663 West Linden Street. The view has been reversed from the original postcard image. To the far right are the three Scarlett houses.

BARNARD HOUSE. Here is a close-up of the home of Amos and Elizabeth Barnard. Amos Barnard is listed in the Boyd's directories of 1904 and 1908 as a florist. Today an office building on West State Street blocks a clear view of the home.

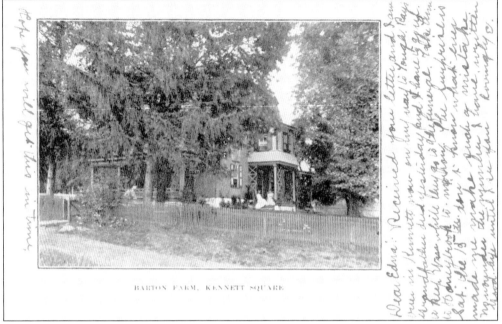

BARTON FARMHOUSE. This Barton farmhouse is located at 233 South Walnut Street. During the Civil War, this home was owned by Harlan Gause and used as a signal station in the Underground Railroad.

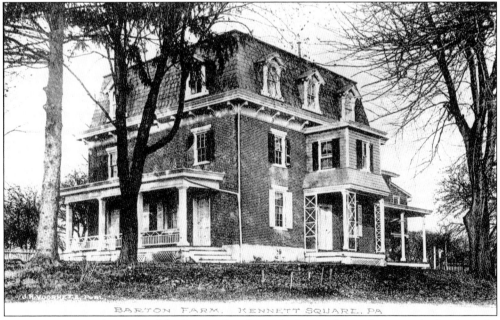

BARTON FARM. This view of the Barton farmhouse looks northeast. At one point in time, the property surrounding the farm was used for foxhunts. The home plays a role in Bayard Taylor's *The Story of Kennett*. Today an apartment house has been built to the south side of the house.

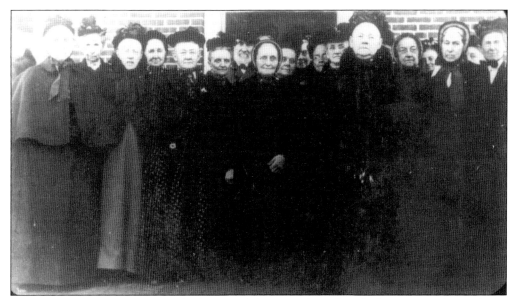

LADIES AND A GENTLEMAN. This lantern slide image dates from before 1900 and may depict a group of local Temperance Union members.

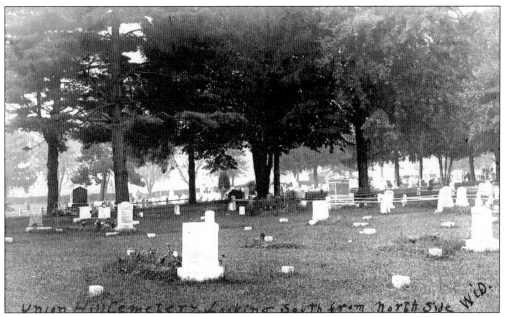

UNION HILL CEMETERY. Pictured here is a real-photo postcard of Union Hill Cemetery, located north of Kennett Square. The ashes of Linda Darnell, the famous Hollywood movie starlet from the 1940s, are buried here (her movies included *My Darling Clementine*, *Anna and the King of Siam*, and *The Mark of Zorro*). Her ashes came to Kennett by way of her adopted daughter, who lived in the area.

RED CLAY CREEK. This postcard shows a rural scene along the Red Clay Creek just outside of Kennett Square.

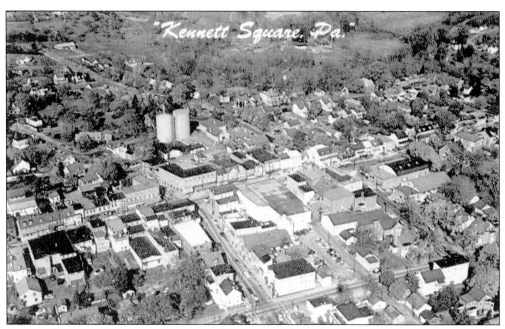

AERIAL VIEW OF KENNETT SQUARE. This postcard dates from between 1956 and 1961. Note the old library building on South Broad Street, the Friends meetinghouse on the right, and the clock atop the firemen's auditorium to the right of center. The water tanks are now gone, having been replaced by a parking garage.

Six

Bayard Taylor, Waywood, and Longwood

LIVE FOR LOVE. This 1905 copyrighted postcard includes a verse by Bayard Taylor: "Live for love, and thou shalt be, Loving others, true to me: Love I follow, follow thee!"

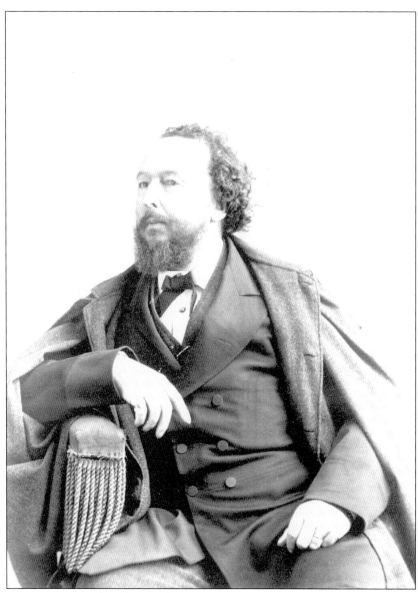

BAYARD TAYLOR. Bayard Taylor was born on January 11, 1825, to Joseph and Rebecca Way Taylor. His first book of poems, *Ximena; or, the Battle of the Sierra Morena, and Other Poems* appeared in 1844. That year, he journeyed throughout Germany, Italy and England. On his return in 1846, he published these letters as *Views A-foot, or, Europe Seen with a Knapsack and Staff.* During 1849 and 1850, he was in California reporting on the gold rush for the *New York Tribune*, and in May 1850, *Eldorado*, an account of his experiences, was published. This work has proven to be his most enduring work, having been published numerous times. On October 24, 1850, he married Mary S. Agnew, but sadly, on December 21, she died of pneumonia. In 1857, he married Marie Hansen, daughter of Peter Andreas Hansen, a distinguished German astronomer. In 1878, President Hayes appointed Taylor Minister to Germany, and although he wrote cheerful letters to the people back home, he was never really well after arriving in Germany. Taylor died in Berlin on December 19, 1878, and was buried in Longwood Cemetery. The photograph above was taken by Napoleon Sarony of New York City and used on many a carte de visite.

HAZELDELL. In 1824, the Taylor family moved to Hazeldell, located on Spottswood Lane in East Marlborough Township, a mile north of Kennett Square.

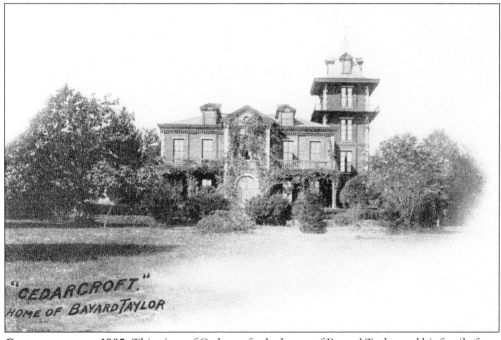

CEDARCROFT, C. 1905. This view of Cedarcroft, the home of Bayard Taylor and his family from 1860 to 1878, was published as part of the Chester County Post Card series about 1905.

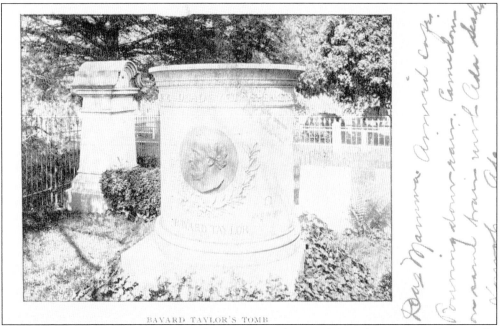

TOMB OF BAYARD TAYLOR, 1905. This private mailing card dates from 1905 and shows the tomb of Bayard Taylor in Longwood Cemetery. To the left rear is the tomb of his brother, Charles Frederic, who died at the Battle of Gettysburg on July 2, 1863.

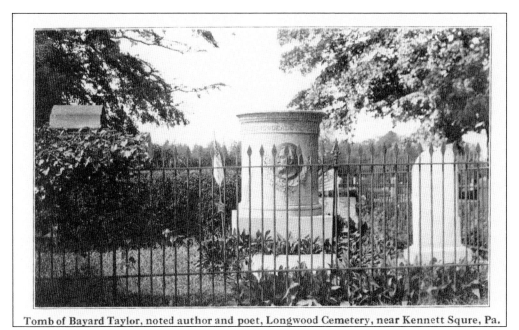

TOMB OF BAYARD TAYLOR. To the right of Taylor's tomb is the gravestone of his first wife, Mary S. Agnew. The gravestone of his second wife, Marie Taylor (née Hansen), is directly in front of Taylor's monument.

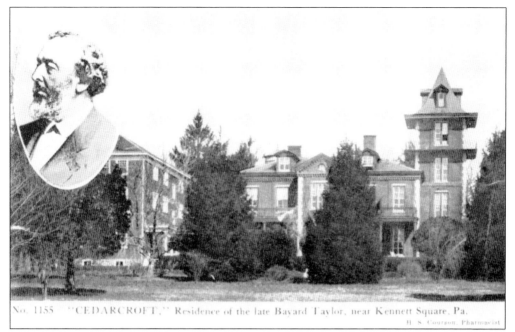

CEDARCROFT AND CEDARCROFT ACADEMY, 1920. This postcard features a side view of Cedarcroft and the Cedarcroft Academy, dating from 1920, published by Ed Herbener of Newark, Delaware, and distributed by local pharmacist Harry S. Courson.

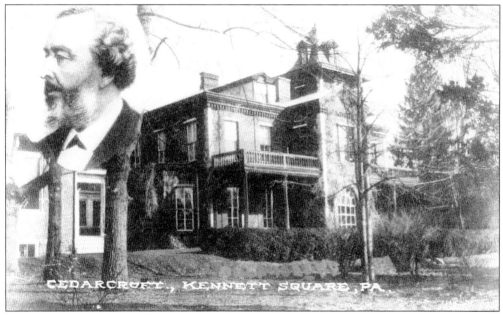

CEDARCROFT. This view of Cedarcroft shows the tower and the side of the mansion. The postcard was published by John H. Voorhees and printed in the 1920s by Louis Kaufman and Sons of Baltimore.

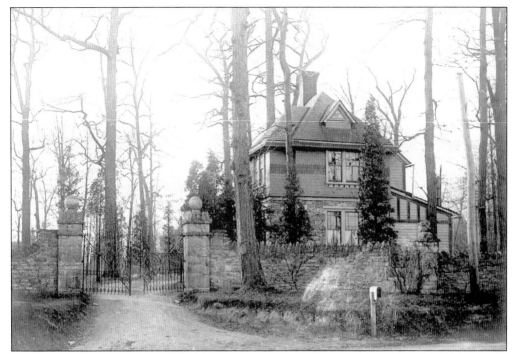

LODGE AT CEDARCROFT. This real-photo postcard shows the lodge at Cedarcroft sometime between 1907 and 1912. Now used as a private residence, it may have been originally used as a guesthouse. Bayard Taylor once wrote, "The gate shall stay open—nailed open if need be, like the hospitable doors of Tartary." (Courtesy of Dolores I. Rowe.)

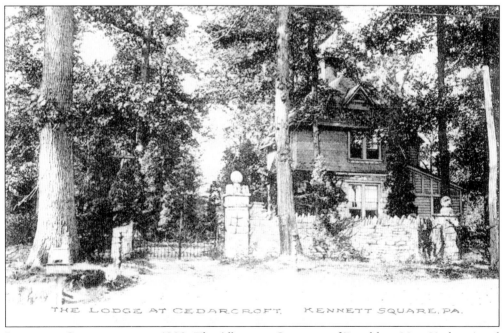

LODGE AT CEDARCROFT, C. 1908. The Albertype Company of Brooklyn, New York, printed this view of the lodge at Cedarcroft for John H. Voorhees about 1908.

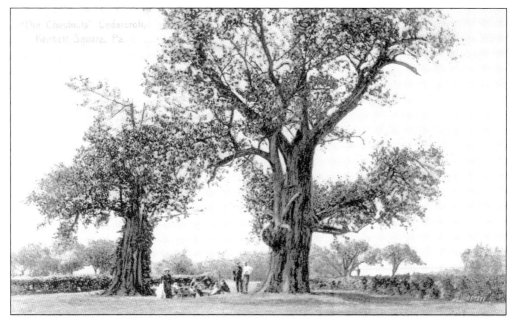

CHESTNUT TREES AT CEDARCROFT. This beautiful postcard shows a few of the chestnut trees found on the estate of Bayard Taylor at Cedarcroft. It appears that a picnic or outing is taking place. Samuel J. Parker of West Chester published this postcard.

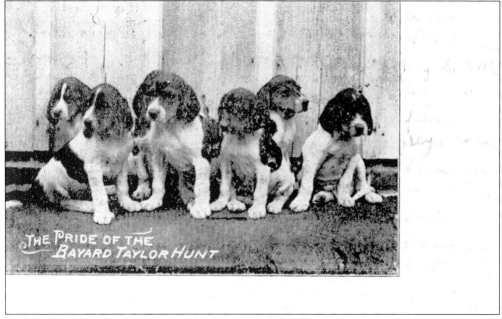

PRIDE OF THE HUNT. This scarce postcard dates from 1905 and shows the Bayard Taylor's *Story of Kennett* Fox Hunt hounds. The first hunt was held in 1896 and took place for many years thereafter.

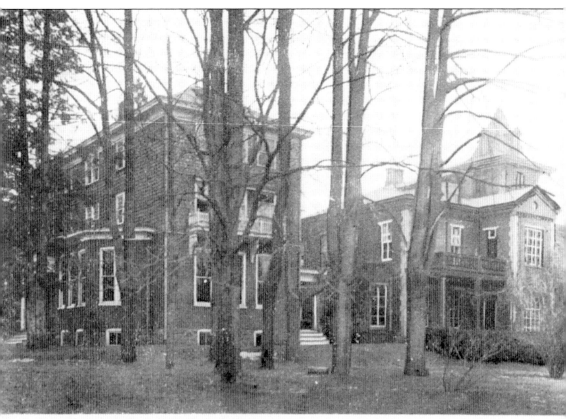

CEDARCROFT SCHOOL, FORMER HOME OF BAYARD TAYLOR, Kennett Square, Pa.

CEDARCROFT AND CEDARCROFT ACADEMY. Cedarcroft passed from the Taylor family in 1882 when Bayard Taylor's wife, Marie, and his daughter, Lilian, sold the remaining 116-acre estate to Isaac Warner Jr. for $14,050 (earlier a 16-acre tract was sold to Mark J. Cox). At the beginning of the 20th century, a men's group from Kennett Square decided to open a private school at Cedarcroft. Its purpose was "to maintain a preparatory and secondary school for boys under the normal conditions of home life." The school was chartered in July 1904, and classes began in September 1905 after a new three-story building was erected behind the mansion. The principal was Jesse Evans Philips, who also taught science and advanced mathematics. The first class began with seven students, and by the end of the first year, there were 15 enrolled with one student graduating. During the next four years (1906-1909), there were between 32 to 40 boys enrolled in each graduating class. The most famous alumnus was Herbert J. Pennock, who arrived at Cedarcroft from Westtown School in 1909 and graduated in the class of 1911. The school yearbook was called *Bagatela* and was first issued in 1910. Pictured above is a side view of Cedarcroft, its tower, and the Cedarcroft Academy building dating from 1920.

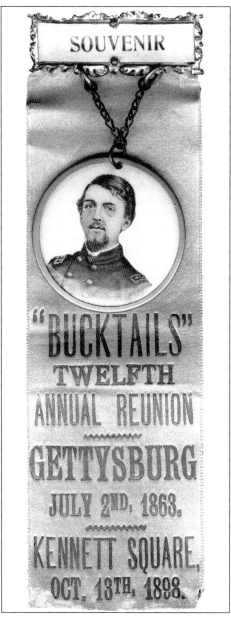

CHARLES FREDERIC TAYLOR AND THE BUCKTAILS. Charles Frederic Taylor was born on February 6, 1840. On Sunday, April 21, 1861, several local men, including Taylor, signed a roster supporting the Union cause and organized themselves as a volunteer company. The group was recruited at Kennett Square on May 15, 1861, as Company H, and mustered on May 28, 1861, for three years' service. During the Civil War, he was a colonel in the Pennsylvania "Bucktail" Regiment (Company H, 42nd Pennsylvania Volunteers). He was captured at Harrisonburg, Virginia, on June 6, 1862. After being paroled, he was wounded at Fredericksburg on December 13, 1862. On March 1, 1863, he was promoted to colonel, the youngest commander in the United States Army. He was killed in action at Gettysburg on July 2, 1863, and is buried at Longwood Cemetery. Shown here is a commemorative ribbon with its Charles Frederic Taylor medallion that was issued for the 1898 reunion of the Bucktails.

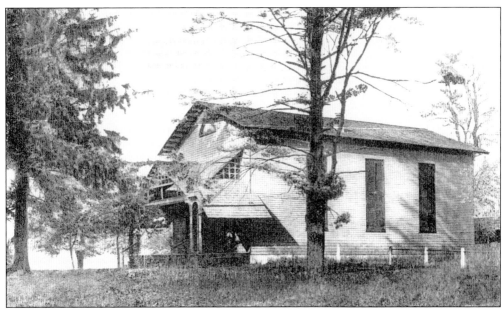

LONGWOOD MEETINGHOUSE. Longwood Meeting was formed on May 22, 1853, by 58 people while attending a gathering of Friends at the Old Kennett Meeting in Hamorton. These Progressive Quakers then built a meetinghouse on ground bought from John Cox. Cox and his wife, Hannah Cox (née Peirce), were well-known conductors on the Underground Railroad. Hannah was a cousin of Joshua and Samuel Peirce of Peirce's Park. Many famous abolitionists were guests at this meetinghouse, including Susan B. Anthony, Frederick Douglass, Thomas Garrett, William Lloyd Garrison, Lucretia Mott, Sojourner Truth, and Harriett Tubman. The name for the meetinghouse was taken from the Cox property, Longwood Farms, which in turn probably took its name from an area of long woods that extended southeasterly from Hamorton to the road to Sills Mills. Pictured below is an earlier view of the meetinghouse dating from 1906.

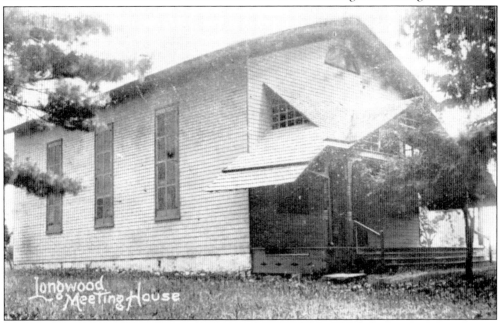

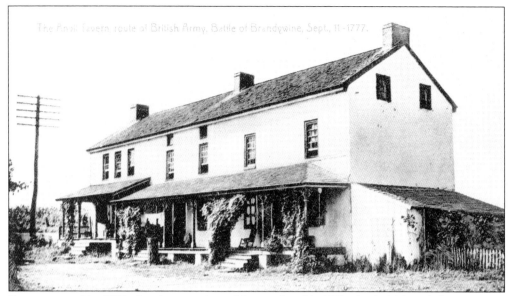

SEPTEMBER 11, 1777. On the morning of September 11, 1777, the British and their Hessian mercenaries left Kennett Square and headed toward the Brandywine to engage George Washington's troops. In the meantime, Washington sent Gen. William Maxwell and his light infantry to the old Kennett meetinghouse to meet the enemy. A patrol Maxwell sent ahead stopped at the Anvil Tavern (originally Welch's Tavern) for a drink. There they were surprised to see the advancing British troops. After firing a few shots, Maxwell's patrol ran back to the meetinghouse without their horses, and thus began the Battle of the Brandywine.

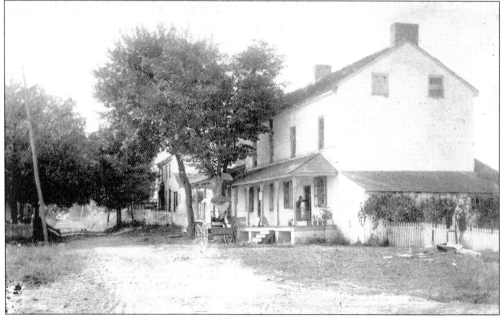

ANVIL TAVERN. Anna Belle Swayne took this photograph sometime between 1890 and 1905. At that time, the old Anvil Tavern was being used as a residence, and from 1909 to 1912, Pierre S. du Pont used it as a boardinghouse for Italian workers he had hired for Longwood Gardens' projects. In 1917, the building was demolished and two homes built for Longwood workers.

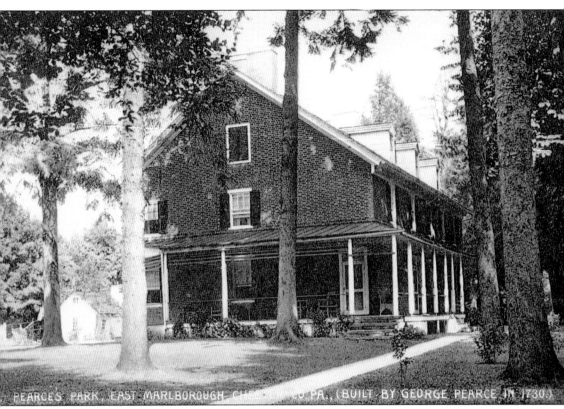

PEIRCE'S PARK. Longwood Gardens began when George Peirce, a Quaker, purchased the original Penn land grant of 402 acres in 1700 for £44 sterling. Peirce gave 200 acres to his daughter and sent his son, Joshua, to build a home on the remaining 200 acres. The log home he built was replaced in 1730 by the red-and-black brick farmhouse shown on the postcard above. Joshua's son, Caleb, bought back the acreage given to George's daughter; Caleb's twin sons, Joshua and Samuel, began to collect trees from about 1798 through the mid-1800s, forming the basis of what became Longwood Gardens. They traveled to the South and neighboring states collecting specimens, which they brought home by traveling at night so the sun would not dry out the plants. Specimens from Europe were also purchased. The Peirces opened the park to the public in the mid-1800s. However, by 1905, the land had passed into the hands of non-family members. Lumber contracts had been signed to cut the trees when Pierre S. du Pont bought the property along with the existing lumber contracts and mortgages in 1906 for $15,500.

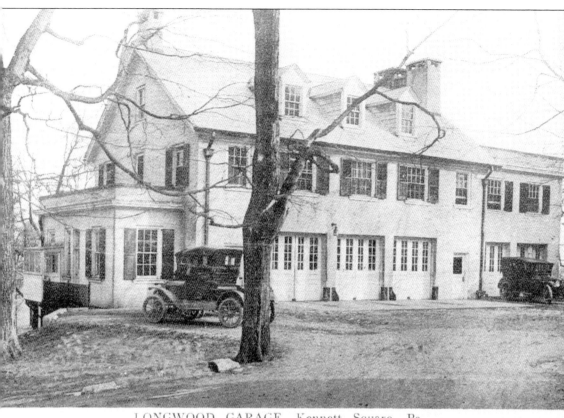

LONGWOOD GARAGE, Kennett Square, Pa.

LONGWOOD GARDENS AND GARAGE. Renamed Longwood, the former Peirce property flourished as Pierre S. du Pont cleaned up, restored, and refurbished the grounds and buildings. Du Pont maintained it as a free public park. The conservatories opened in November 1921 and caused a huge increase in the number of visitors. Attendance in 1922 was 22,000, but by 1971, it had grown to 1.1 million. Du Pont continued to improve the gardens with added features such as the Italian Water Garden, the main fountain garden, and the topiary garden with the analemmatic sundial. He expanded the conservatory with a large ballroom, including a 10,010-pipe organ. To ensure that Longwood Gardens would be able to operate after his death, du Pont petitioned for the gardens to qualify for tax-exempt status as an educational institution serving the public. This was approved in 1946. Du Pont died in 1954, but left his wonderful legacy for all to enjoy. Published by A. M. Simon of New York, this *c.* 1917 postcard shows the garage behind the Peirce-du Pont house. Du Pont had a tunnel built from the garage to the residence for his convenience.

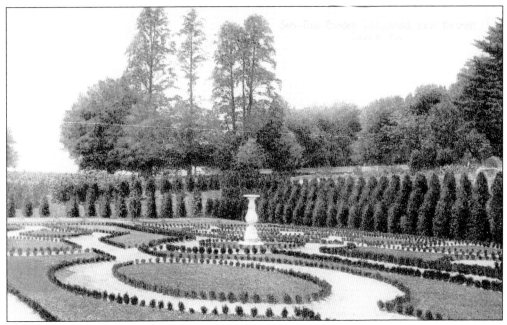

LONGWOOD GARDENS. Published by Samuel J. Parker of West Chester, the postcard above, from the second decade of the 20th century, shows the Sun Dial Garden.

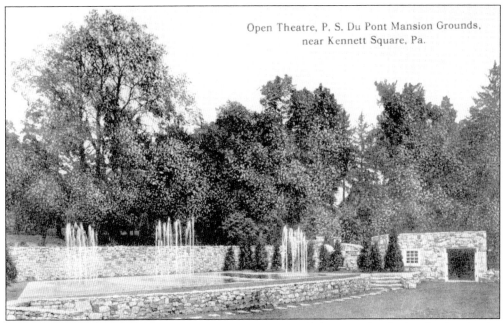

OPEN THEATRE. Here is the Open Theatre at Longwood about 1918. The inspiration for the fountains came from France and Italy. In 1927, the theater was redesigned by adding a slope to the auditorium, dressing rooms under the stage, and fountains (including a water curtain) on the stage floor.

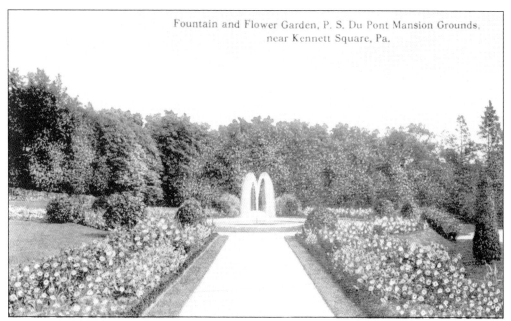

FOUNTAIN AND FLOWER GARDEN. Published in the 1920s by Louis Kaufmann and Sons, the postcard above shows the fountain and flower garden.

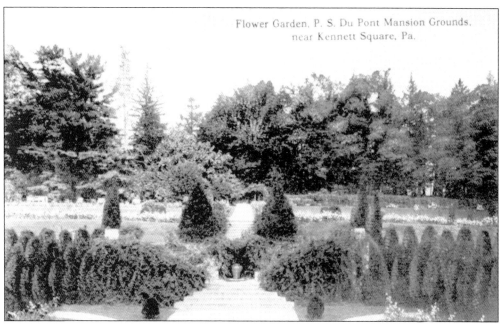

LONGWOOD GARDENS, 1920S. The postcard above shows the flower garden and was also published by Louis Kaufman and Sons of Baltimore in the 1920s.

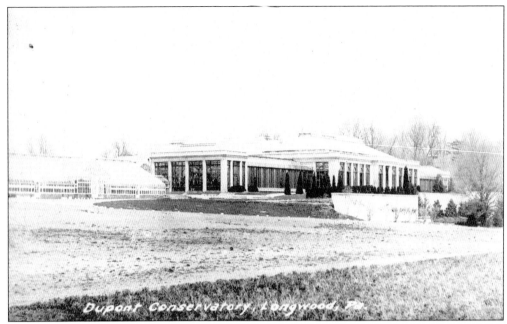

DU PONT CONSERVATORY. This real-photo postcard shows the Du Pont Conservatory at Longwood. The conservatories were the largest single construction effort at Longwood Gardens and have attracted more attention than any other displays.

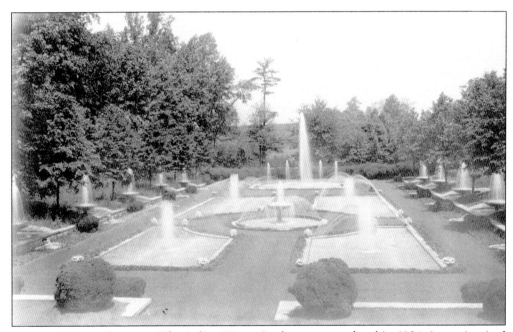

ITALIAN WATER GARDEN. The Italian Water Garden was completed in 1926. It was inspired by a trip to Florence, Italy, by Mr. du Pont, who designed the garden himself. The far pools are 14 feet longer than the closer ones so that at a distance they appear equal. (Courtesy of Dolores I. Rowe.)

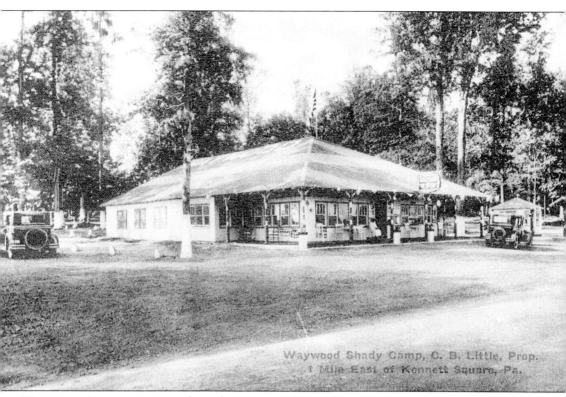

Waywood Shady Camp, C. B. Little, Prop. 1 Mile East of Kennett Square, Pa.

WAYWOOD SHADY CAMP. In the early 1920s, C. B. Little purchased a 7.5-acre wooded tract from the Way brothers and founded Waywood Shady Camp one mile east of Kennett Square. It was sold to W. F. Hauseman in 1926 for $30,000, and according to the *Daily Local News* of September 12, 1941, "Mr. Hauseman spent $15,000 additional in improvements building cabins, dining rooms, two kitchens, putting in oil heat, gas and electricity and establishing an up-to-date gas station." It was "synonymous for years for all that tends to the needs of the traveling public and was frequented by people from all over the country. Longwood pageants always meant an upswing in business." In 1941, George A. Haupt purchased the facility with the hopes of doubling the number of cabins and updating "in keeping with the needs of the modern tourist world." World War II and the later arrival of numerous motels around the country put an end to this facility. It was later the home of Waywood Beverage Company, then for many years a fruit and vegetable stand, until the main building was torn down in January 2001, when the Bayard Taylor Memorial Library purchased the property.

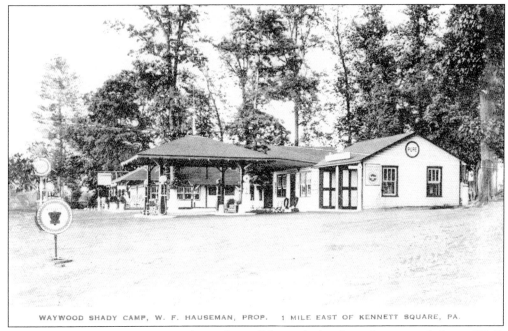

WAYWOOD SHADY CAMP. Note the various oil logos depicted on the postcard above. W. F. Hauseman owned the property at the time of this postcard.

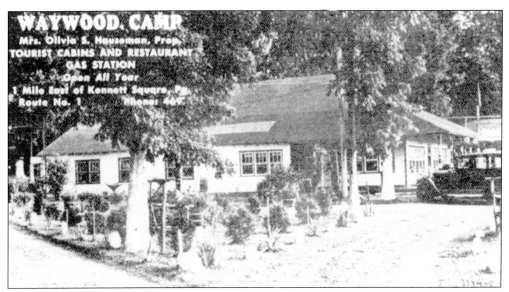

THE MAIN OFFICE. Seen here are the main office of the Waywood Shady Camp and what appears to be a garden at the time when Olivia S. Hauseman was the proprietor.

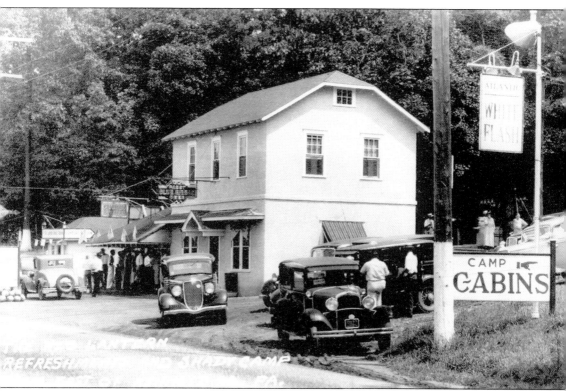

THE RED LANTERN. The Red Lantern Tourist Camp and Service Station was a landmark in the Kennett area for many years. About 1930, two brothers, Joseph and Sopino Di Norscia, and Giacomo Ranalli established the Red Lantern. The Red Lantern offered sandwiches and drinks at the frame refreshment stand, gas and service, and seven or eight cabins for overnight visitors. During World War II, the Red Lantern was leased to Charlie Traversa, who later became the proprietor. It subsequently passed through several other owners before being bought and converted for use today as the Waywood Beverage Company, established in 1961. The Red Lantern had the largest television in Chester County, and after remodeling in 1947, an orchestra played every Friday evening. As the business grew, the two-story building pictured above was added. The original refreshment stand can be seen with customers lined up outside on the left of the postcard, but sit-down dinners were served in the new building. Note the Atlantic White Flash sign, plus ads for Pabst Blue Ribbon and Sharpless Ice Cream. Today, this part of Kennett Square is known as Millers Hill.

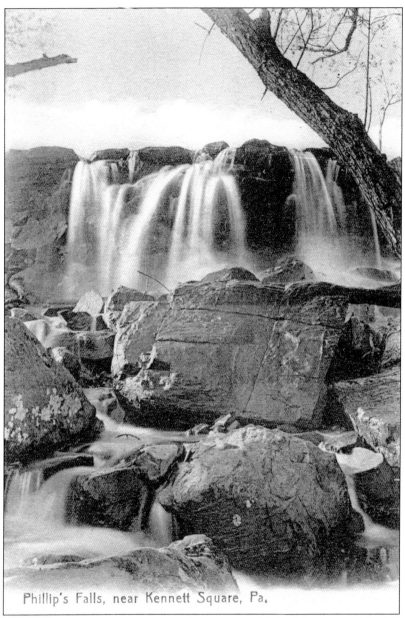

Phillip's Falls, near Kennett Square, Pa.

Phillips' Falls. W. J. Berkstresser, a local pharmacist, published this view of the falls in 1908. The falls, located on the east branch of the Red Clay Creek, were adjacent to the large stone paper mills of William H. Phillips, who purchased the property from John Wright in 1888. On the property was a 33-foot oak waterwheel, thought to be the largest in Chester County. According to the *Kennett News & Advertiser*, "it was fed from a race from a dam across Red Clay Creek which, at that point, had a rapid fall for a distance of a quarter of a mile." Supposedly under the dam was a natural cavity known as "Sandy Flash's Cave," a hideout for the highwayman from Bayard Taylor's *The Story of Kennett*. Cardboard and, for a time, tissue paper were produced at these mills. The mills were destroyed by fire on April 13, 1892. The boulders were of hornblend rock, and the falls were located on what is now Creek Road (Pennsylvania Route 82) just north of Hillendale Road. One can still see the boulders lining the creek bed.

Seven
Sports, Recreation, and Miscellaneous

Mohican Season Ticket. This is a 1904 season ticket for the Mohican Baseball Club, which played at Sharpless' Park. It was also good for immediate family members. (Courtesy of the Chester County Historical Society.)

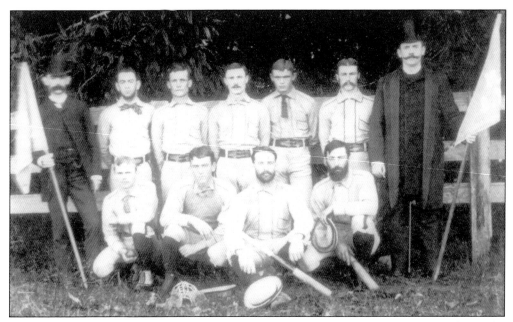

THE MOHICANS. The photograph above was taken from a glass lantern slide and shows the Mohican Baseball Club of Kennett Square in 1886. Shown in the photograph from left to right are (first row) Harry Whiteacre, Tim Grady, Theodore Pennock (father of Herb Pennock), and Charles J. Pennock; (second row) William P. Mercer (manager), C. Sharpless Mercer, Thomas Grady, Joseph and Jack Keating, C. B. Hannum, and John M. Chalfant (manager). Thomas and Tim Grady were brothers of Mike Grady (pictured below). In 1895, the Mohican Baseball Club won the Chester County league title.

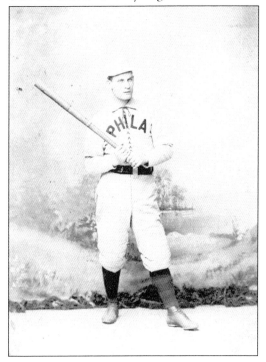

MIKE GRADY. This carte de visite shows Michael (Mike) W. Grady (1869–1943) in a Phillies uniform in 1894. He was the first resident of Kennett Square to achieve acclaim in organized baseball. He began his career playing for the Mohican Baseball Club and Brandywine Club of West Chester. He moved on to the Penn State League in 1893, and between 1894 and 1906, he played in the two major leagues. After 18 years in the professionals, he retired in 1910.

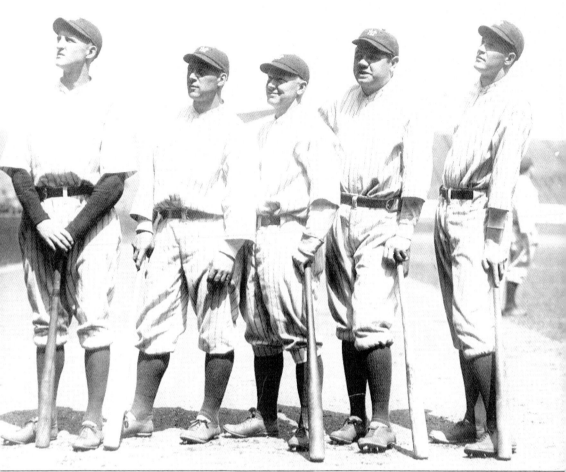

HERB PENNOCK. Herbert Jefferis Pennock was born in Kennett Square on February 10, 1894, to Theodore and M. Louise Sharp Pennock. The "Squire of Kennett Square" began his major league career with the Philadelphia Athletics in 1912. After four seasons, he was traded to the Boston Red Sox, where he pitched alongside Babe Ruth. Ruth was traded to the New York Yankees in 1920, and Herb followed him three years later. Herb was an immediate hit in his first year at Yankee Stadium, winning 19 of 25 decisions for a league-leading .760 percentage. He also won two games in the 1923 World Series and eventually posted a 5-0 World Series record for his career. Herb remained with the Yankees until 1933. After 22 major league seasons, Herb retired, but he returned to coach in Boston from 1936 to 1940. In 1943, he became general manager of the Philadelphia Phillies. Herb died on January 30, 1948, and was elected to the Baseball Hall of Fame on February 28, 1948. Pictured above is Herb Pennock, on the left, with Babe Ruth, second from the right, along with other members of the Yankees team. (Courtesy of Robert A. Burton, Burton's Barber Shop.)

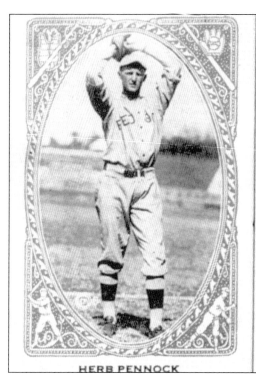
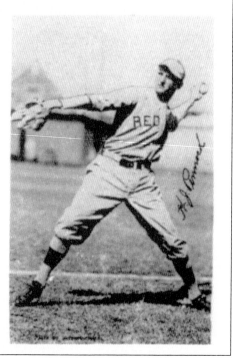

EARLY PENNOCK BASEBALL CARDS. On the left is a 1922 American Caramel Company card (No. 9), and on the right is a 1923 Maple Crispette card (No. 27).

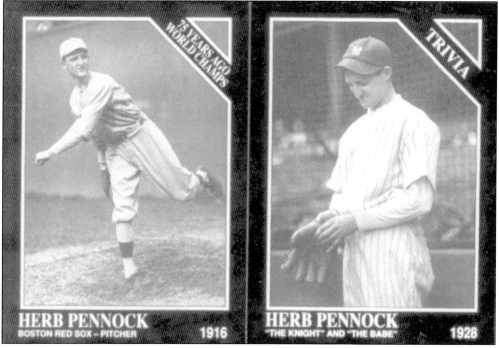

THE SPORTING NEWS. The Conlon baseball card (No. 143) on the left dates from 1991 and the Conlon baseball card (No. 594) on the right from 1992.

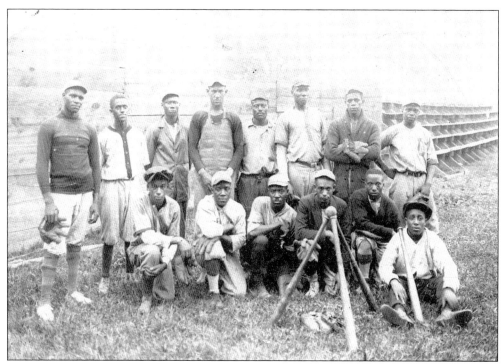

BLACK BASEBALL TEAM. The photograph above was taken in the 1920s and shows members of a local black baseball team. (Courtesy of Mabel L. Thompson.)

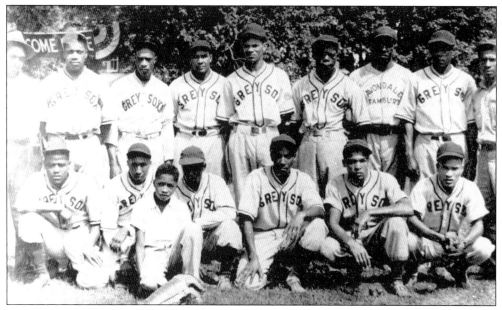

THE GREY SOX. Pictured here are the Grey Sox in 1946, when the team was the winner of the first half of the season and runners-up in the Community League. It is said that this team was one of the most interesting local teams to watch and always drew good crowds. (Courtesy of Mabel L. Thompson.)

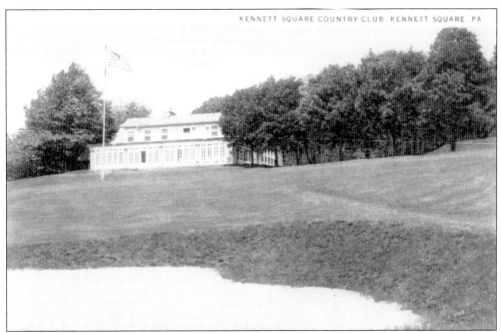

KENNETT SQUARE COUNTRY CLUB. The club, chartered on November 18, 1922, is located just north of town. The first president was John M. Chalfant.

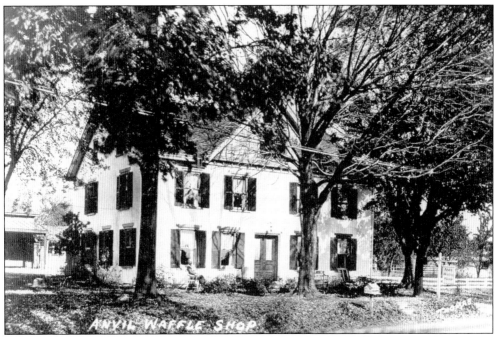

THE COX HOME. Built in 1797, the Anvil is most famous as the home of John Cox and Hannah Cox (née Peirce), important conductors on the Underground Railroad. It originally had a porch reaching to the second floor and a widow's walk on the roof. Most recently, the home served as a Waffle Shop and, later, as a real estate office. It is now owned by Longwood Gardens and is located at 923 East Baltimore Pike.

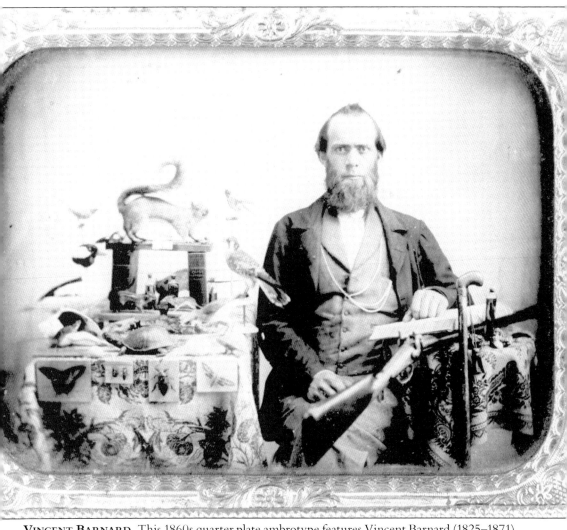

VINCENT BARNARD. This 1860s quarter plate ambrotype features Vincent Barnard (1825–1871), a true student of the natural sciences. He was employed at the S. and M. Pennock Company from 1853 to 1866 and was a master mechanic, able to repair any tool or piece of machinery. But his true passion was the natural sciences, having been a protégé of Dr. William Darlington of West Chester. By the age of 16, he had a collection of over 3,000 specimens, including birds, insects, and plants. In 1848, he wrote an essay on entomology describing 480 specimens. He had a botanical garden at his home at 315 East Linden Street with 400 trees and shrubs native to Chester County and, around 1865, a small museum. Barnard was first married to Joanna Pennock (1828–1866), daughter of Moses Pennock and sister of Samuel. He and Joanna had one son, Moses Pennock Barnard (1860–1898). After Vincent's death, his collection was purchased by Swarthmore College, where it was later destroyed in a fire. (Courtesy of the Chester County Historical Society.)

Discover Thousands of Local History Books
Featuring Millions of Vintage Images

Arcadia Publishing, the leading local history publisher in the United States, is committed to making history accessible and meaningful through publishing books that celebrate and preserve the heritage of America's people and places.

Find more books like this at
www.arcadiapublishing.com

Search for your hometown history, your old stomping grounds, and even your favorite sports team.

Consistent with our mission to preserve history on a local level, this book was printed in South Carolina on American-made paper and manufactured entirely in the United States. Products carrying the accredited Forest Stewardship Council (FSC) label are printed on 100 percent FSC-certified paper.